FEAR THIS

A Nation at War

ANTHONY SUAU

APERTURE

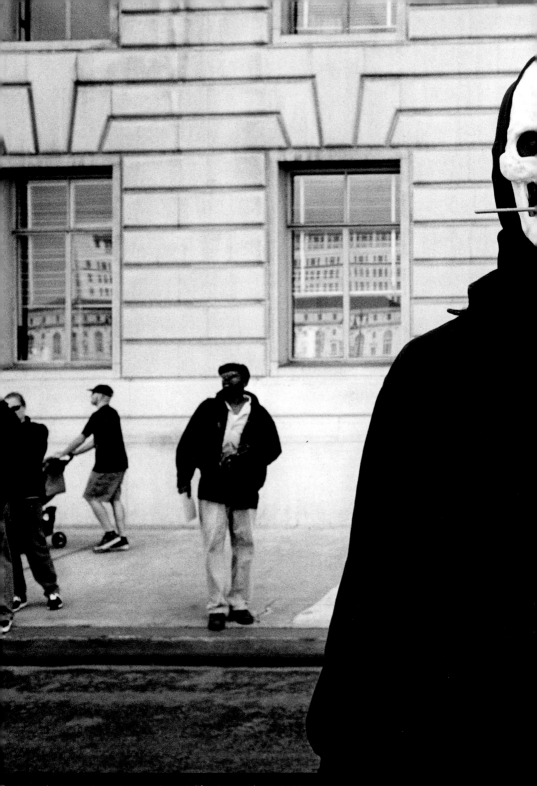

Anti-war demonstration, San Francisco, California, March 15, 2003

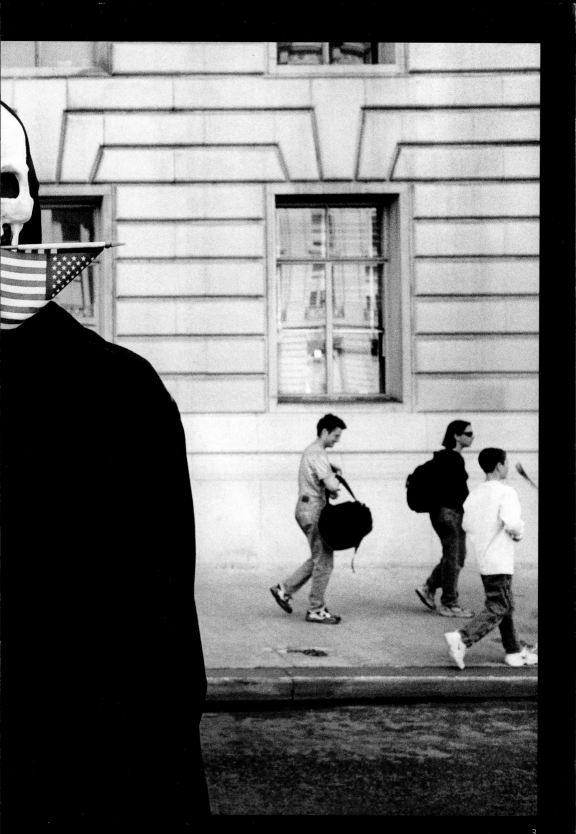

For all the American, British, Iraqi, and other families who have
had loved ones injured or killed in Iraq since March 19, 2003

September 12 U.S. President George W. Bush challenges the United Nations to force Saddam Hussein to disarm, implying that if he does not, the United States might take military action.

November 8 The U.N. Security Council unanimously adopts Resolution 1441, demanding Iraqi disarmament.

November 27 Nearly 4 years after withdrawing from Iraq, U.N. inspectors begin searching for banned weapons programs.

December 7 Iraq delivers a 12,000-page declaration on banned weapons to the U.N., meeting a Security Council deadline. Iraqi officials say the documents state that they have no weapons of mass destruction and no current programs to develop them.

January 22 The Bush administration confronts European skeptics of military action against Iraq. Defense Secretary Donald H. Rumsfeld dismisses Germany and France, saying "that's old Europe."

January 27 Chief U.N. weapons inspector, Hans Blix, gives a negative report on Iraq's cooperation with 2 months of inspections, saying, "Iraq appears not to have come to genuine acceptance."

January 28 In his State of the Union address, President Bush indicates that the U.S. is prepared to use force in Iraq, even in the face of allied objections and without explicit U.N. Security Council approval.

February 5 Secretary of State Colin Powell presents photographs, intercepts of conversations, and information from defectors hoping to prove that Saddam Hussein poses an imminent danger. Envoys of France, Russia, and China suggest that the evidence reinforces their view that the inspectors need more time.

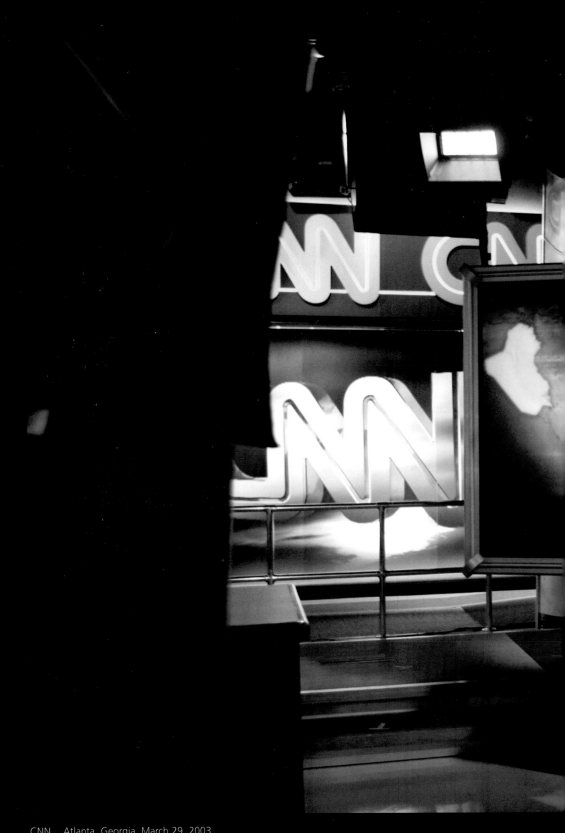

CNN. Atlanta, Georgia, March 29, 2003

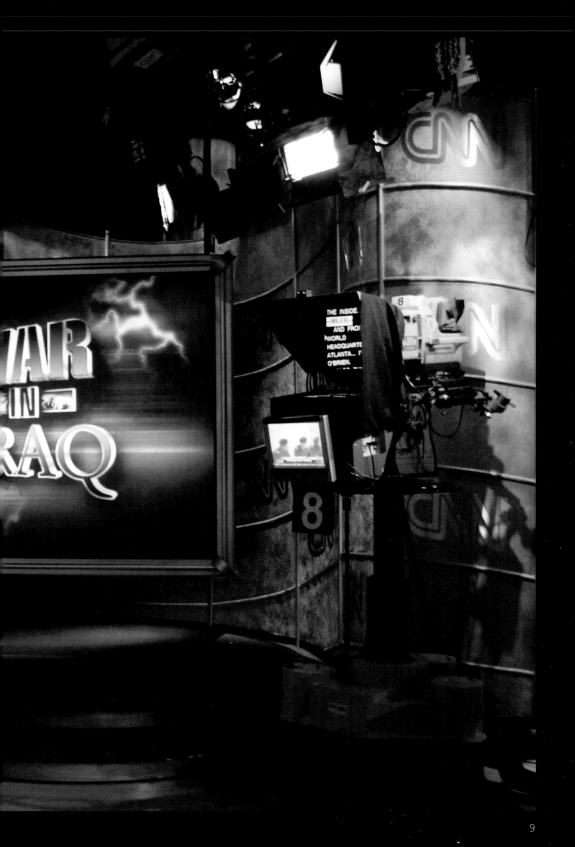

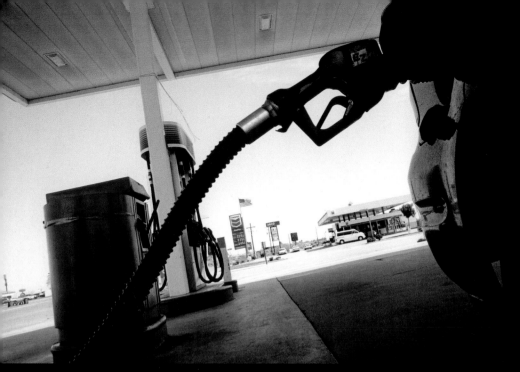

Blackwells Corner, California, March 19, 2003

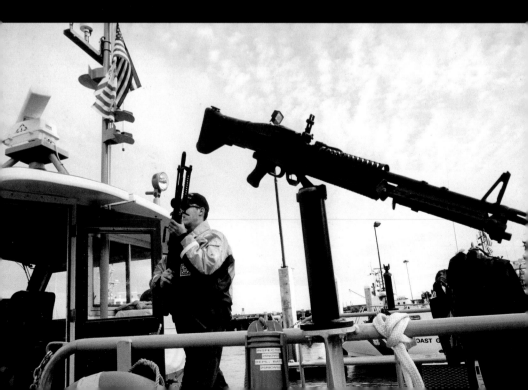

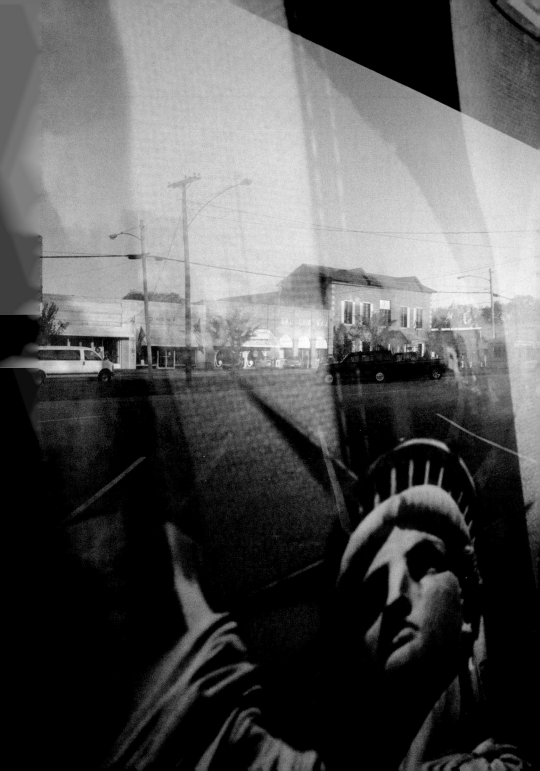

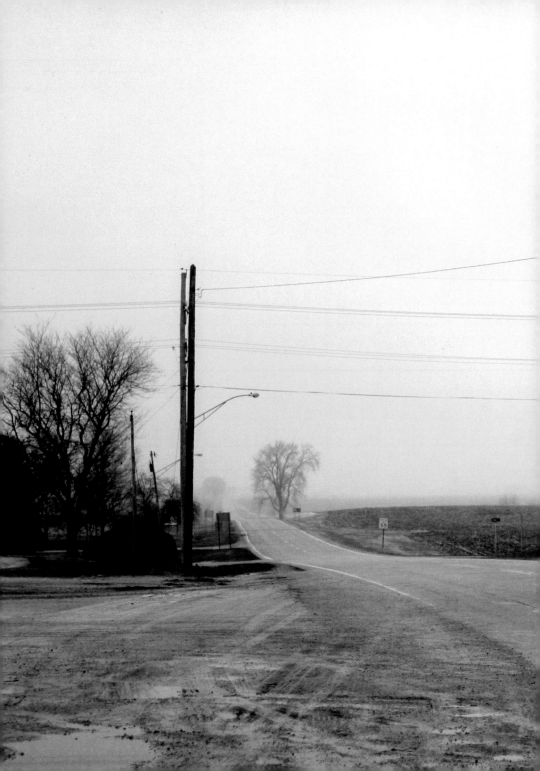

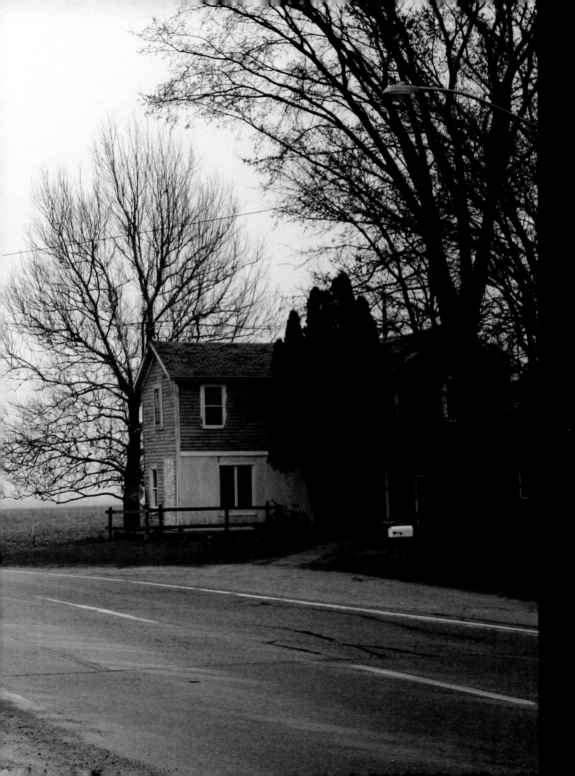

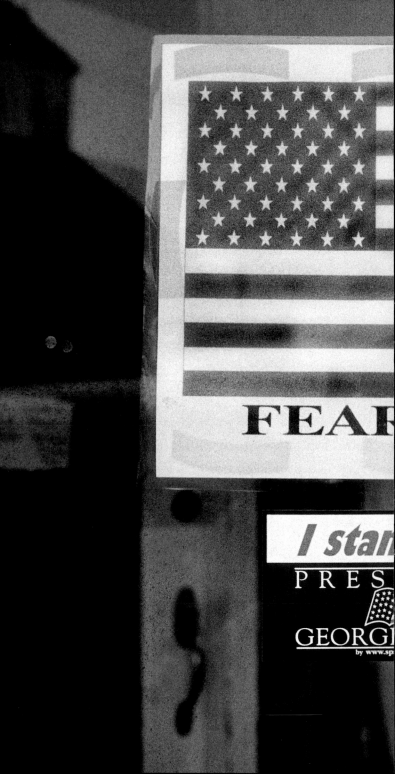

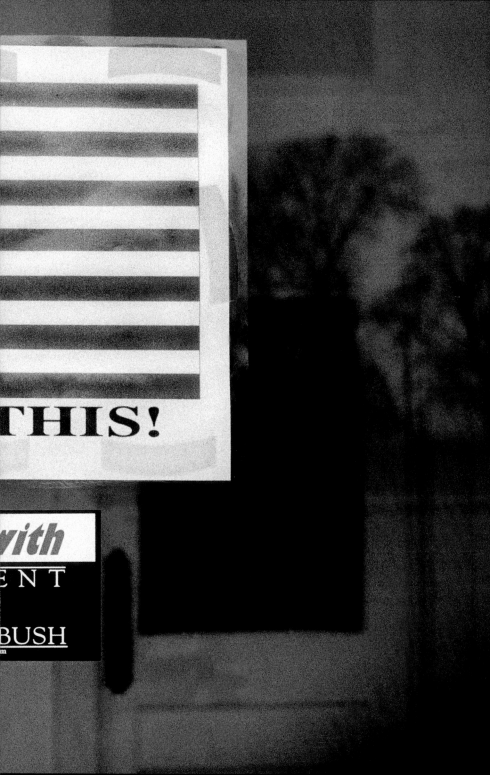

In May 2003, New York Times *correspondent* **Chris Hedges** *gave the Commencement Address at Rockford College in Rockford, Illinois. During the speech the audience continuously disrupted him.*

I want to speak to you today about war and empire. The killing, or at least the worst of it, is over in Iraq. Although blood will continue to spill—theirs and ours—be prepared for this. For we are embarking on an occupation that, if history is any guide, will be as damaging to our souls as it will be to our prestige, power, and security. But this will come later, as our empire expands. And in all this we become pariahs, tyrants to others weaker than ourselves. Isolation always impairs judgment, and we are very isolated now.

We have forfeited the goodwill, the empathy the world felt for us after 9/11. We have folded in on ourselves, we have severely weakened the delicate international coalitions and alliances that are vital in maintaining and promoting peace. And we are now part of a dubious troika in the war against terror with Vladimir Putin and Ariel Sharon, two leaders who do not shrink in Palestine or Chechnya from carrying out acts of gratuitous and senseless violence. We have become the company we keep.

The censure, and perhaps the rage, of much of the world—certainly the one-fifth of the world's population which is Muslim, most of whom I will remind you are not Arab—is upon us. Look today at the fourteen people killed last night in several explosions in Casablanca. And this rage, in a world where almost fifty percent of the planet struggles on less than two dollars a day, will see us targeted. Terrorism will become a way of life. And when we are attacked, we will, like our allies Putin and Sharon, lash out with greater fury.

The cycle of violence is a death spiral; no one escapes. We are spinning at a speed that we may not be able to halt. As we revel in our military prowess—the sophistication of our military hardware and technology, for this is what most of the press coverage consisted of in Iraq—we lose sight of the fact that just because we have the capacity to wage war does not give us the right to wage war. This capacity has doomed empires in the past.

"Modern Western civilization may perish," the theologian Reinhold Niebuhr warned, "because it falsely worshipped technology as a final good."

The real injustices—the Israeli occupation of Palestinian land, the brutal and corrupt dictatorships we fund in the Middle East—will mean that we will not rid the extremists who hate us with bombs. Indeed, we will swell their ranks. Once you master people by force, you depend on force for control. In your isolation, you begin to make mistakes. *("Where were you on September 11?")*

Fear engenders cruelty; cruelty . . . fear, insanity, and then paralysis. *(Hoots. "Who wants to listen to this jerk?")* In the center of Dante's circle, the damned remained motionless. We have blundered into a nation we know little about and are caught between bitter rivalries and competing ethnic groups and leaders we do not understand.

We are trying to transplant a modern system of politics invented in Europe, characterized, among other things, by the division of the Earth into independent secular states based on national citizenship in a land where the belief in a secular civil government is an alien creed. Iraq was a cesspool for the British when they occupied it in 1917. It will be a cesspool for us, as well.

("God bless America," a woman yells.)

The curfews. The armed clashes with angry crowds that leave scores of Iraqi dead. The military governor. The Christian evangelical groups that are being allowed to follow on the heels of our occupying troops to try and teach Muslims about Jesus. The occupation of the oil fields. . .

(The microphone is unplugged. When it is fixed, Rockford College President Paul Pribbenow addresses the audience: "My friends, one of the wonders of a liberal arts college is its ability and its deeply held commitment to academic freedom and the decision to listen to each other's opinions. If you wish to protest the speaker's remarks, I ask that you do it in silence, as some of you are doing in the back. That is perfectly appropriate, but he has the right to offer his opinion here, and we would like him to continue his remarks." People blow horns and boo, and there is some applause. A man says, "When did liberal arts become liberal?")

* The occupation of the oil fields. *(More boos. A woman says, "We're not going to listen. We've listened enough. You've already ruined our graduation. Don't ruin it any more, sir.")*
* The notion that the Kurds and the Shiites will listen to the demands of a centralized government in Baghdad (the same Kurds and Shiites who died by the tens of thousands in defiance of Saddam Hussein, a man who happily butchered all of those who challenged him, and this ethnic rivalry has not gone away).
* The looting of Baghdad, or let me say the looting of Baghdad with the exception of the oil ministry and the interior ministry—the only two ministries we bothered protecting—is self-immolation.

As someone who knows Iraq, speaks Arabic, and spent seven years in the Middle East, if the Iraqis believe rightly or wrongly that we come only for oil and occupation, they will begin a long, bloody war of attrition. It is how they drove the British out. And remember that, when the Israelis invaded southern Lebanon in 1982, they were greeted by the dispossessed Shiites as liberators, but within a few months, when the Shiites saw that the Israelis had come not as liberators but as occupiers, they began to kill them. It was Israel that created Hezbollah, and it was Hezbollah that pushed Israel out of southern Lebanon.

As William Butler Yeats wrote in "Meditations in Times of Civil War," "We had fed the heart on fantasies / the heart's grown brutal from the fare." *(Horns. "I never would have come if I knew I had to listen to this," a woman yells.)*

This is a war of liberation in Iraq, but it is a war now of liberation by Iraqis from American occupation. And if you watch closely what is happening in Iraq, if you can see it through the abysmal coverage, you can see it in the lashing out of the terrorist death squads, and the murder of Shiite leaders in mosques, and the assassination of our young soldiers in the streets. It is one that will soon be joined by Islamic radicals, and we are far less secure today than we were before we bumbled into Iraq. *("U.S.A., U.S.A.," a section of the crowd chants.)*

We will pay for this, but what saddens me most is that those who will, by and large, pay the highest price are poor kids from Mississippi or Alabama or Texas who could not get a decent job or health insurance and joined the Army because it was all we offered them. For war in the end is always about betrayal, betrayal of the young by the old, of soldiers by politicians, and of idealists by cynics.

Read *Antigone*, when the king imposes his will without listening to those he rules, or Thucydides' history. Read how Athens' expanding empire saw it become a tyrant abroad and then a tyrant at home, how the tyranny the Athenian leadership imposed on others it finally imposed on itself.

This, Thucydides wrote, is what doomed Athenian democracy; Athens destroyed itself. For the instrument of empire is war, and war is a poison, a poison that at times we must ingest just as a cancer patient must ingest a poison to survive. But if we do not understand the poison of war—if we do not understand how deadly that poison is—it can kill us just as surely as the disease. *("It's enough, it's enough, it's enough," a woman says.)*

We have lost touch with the essence of war. Following our defeat in Vietnam we became a better nation. We were humbled, even humiliated. We asked questions about ourselves we had not asked before.

We were forced to see ourselves as others saw us, and the sight was not always a pretty one. We were forced to confront our own capacity for atrocity—for evil—and in this we understood not only war but more about ourselves. But that humility is gone.

War, we have come to believe, is a spectator sport. The military and the press—remember in wartime the press is always part of the problem—have turned war into a vast video arcade game. Its very essence—death—is hidden from public view.

There was no more candor in the Persian Gulf War or the war in Afghanistan or the war with Iraq than there was in Vietnam. But in the age of live feeds and satellite television, the state and the military have perfected the appearance of candor.

Because we no longer understand war, we no longer understand that it can all go horribly wrong. We no longer understand that war begins by calling for the annihilation of others but ends, if we do not know when to make or maintain peace, with self-annihilation. We flirt, given the potency of modern industrial weapons, with our own destruction. *("That's not true!")*

The seduction of war is insidious because so much of what we are told about it is true: It does create a feeling of comradeship, which obliterates our alienation and makes us, for perhaps the only time of our life, feel we belong.

War allows us to rise above our small stations in life. We find nobility in a cause and feelings of selflessness and even bliss. And at a time of soaring deficits and financial scandals and the very deterioration of our domestic fabric, war is a fine diversion. War, for those who enter into combat, has a dark beauty, filled with the monstrous and the grotesque. The Bible calls it the lust of the eye and warns believers against it. War gives us a distorted sense of self; it gives us meaning.
(Shouts of "Go home!" A man climbs on the stage next to Mr. Hedges saying, "Can I say a few words here?" He is hastily removed by campus security. And Hedges responds, "When I finish, yeah.")

Once in war, the conflict obliterates the past, and the future is all one heady, intoxicating present. You feel every heartbeat in war, colors are brighter, your mind races ahead of itself.
(Boos, and the microphone again is unplugged momentarily. "Should I keep going?" Hedges asks President Pribbenow, who responds, "It's up to you." Hedges asks, "Do you want me to stop?"

Pribbenow says, "How close are you? Why don't you bring it to a close?" Hedges says, "All right, I'll bring it to a close." More shouts of "Go home!" One person yells, "It's not your graduation.")

We feel in wartime comradeship. *(Many loud boos.)* We confuse this with friendship, with love. There are those who will insist that the comradeship of war is love. The exotic glow that makes us in war feel as one people, one entity, is real, but this is part of war's intoxication.

Think back on the days after the attacks on 9/11.

Suddenly, we no longer felt alone; we connected with strangers, even with people we did not like. We felt we belonged, that we were somehow wrapped in the embrace of the nation, the community. In short, we no longer felt alienated. *("Go home!")*

As this feeling dissipated in the weeks after the attack, there was a kind of nostalgia for its warm glow. And wartime always brings with it this comradeship, which is the opposite of friendship. Friends, as J. Glenn Gray points out, are predetermined; friendship takes place between men and women who possess an intellectual and emotional affinity for each other. But comradeship—that ecstatic bliss that comes with belonging to the crowd in wartime—is within our reach. We can all have comrades.

The danger of the external threat that comes when we have an enemy does not create friendship; it creates comradeship. And those in wartime are deceived about what they are undergoing. This is why once the threat is over, once war ends, comrades again become strangers to us. This is why, after war, we fall into despair. *("Atheist Stranger!")*

In friendship, there is a deepening of our sense of self. We become, through the friend, more aware of who we are and what we are about. We find ourselves in the eyes of the friend. Friends probe and question and challenge each other to make each of us more complete. In comradeship, the kind that comes to us in patriotic fervor, there is a suppression of self-awareness, self-knowledge, and self-possession. Comrades lose their identities in wartime for the collective rush of a common cause—a common purpose. In comradeship there are no demands on the self. This is part of its appeal and one of the reasons we miss it and seek to recreate it. *("Go home! Go home!")* Comradeship allows us to escape the demands on the self that is part of friendship.

In wartime when we feel threatened, we no longer face death alone but as a group, and this makes death easier to bear. We ennoble self-sacrifice for the other, for the comrade. (Boos.) In short, we begin to worship death. And this is what the god of war demands of us.

Think finally of what it means to die for a friend. It is deliberate and painful; there is no ecstasy. For friends, dying is hard and bitter. The dialogue they have and cherish will perhaps never be recreated. Friends do not, the way comrades do, love death and sacrifice. To friends, the prospect of death is frightening. And this is why friendship—or, let me say, love—is the most potent enemy of war. Thank you.

(Loud boos, whistles, horns, a little applause. A man says, "This is the most destructive thing you've ever done to this college, Dr. Pribbenow. You should never have allowed him to speak.")

March 7, 2003

It will take several months to check whether Iraq has complied fully with its disarmament obligations, says chief United Nations weapons inspector Hans Blix. "It will not take years, nor weeks, but months," he states. Mohamed ElBaradei, the head of the International Atomic Energy Agency, submits a report to the U.N. Security Council in which he states there is no evidence of a revival of Iraq's nuclear weapons program.

U.S. Secretary of State Colin Powell responds by saying that Iraq's disarmament efforts have not amounted to the voluntary, active cooperation demanded by U.N. resolutions.

By contrast, French Foreign Minister Dominique de Villepin says there is significant evidence of real disarmament. Iraq is less of a threat to the world than it was before the 1991 Gulf War, he adds. Russian counterpart, Vladimir Putin, tells President Bush that Moscow prefers the diplomatic route.

U.S. President George W. Bush claims it is time for Council members to "show their cards—and to let the world know where they stand when it comes to Saddam." The U.N. weapons inspectors do not need more time, nor more personnel. All they need is the full cooperation of the Iraqi regime, he says.

February 14, 2003

The chief U.N. arms inspector Hans Blix tells the U.N. Security Council that Iraq needs to provide evidence that it does not possess banned weapons. But he takes a more positive line than in his last U.N. report, saying Baghdad had made progress in a number of areas.

Dr. Mohamed ElBaradei repeats his finding that his inspectors have discovered no evidence that Iraq was restarting its nuclear program.

Mr. de Villepin states that, "France believes . . . the option of inspections has not been taken to the end . . . and the use of force would be so fraught with risk that it could only be envisioned as a last resort. . . .There is an alternative to war, disarming Iraq through inspections."

Iraq has lied and concealed its weapons of mass destruction and in doing so has undermined the authority of the U.N., claims U.K. foreign secretary Jack Straw.

DIPLOMACY

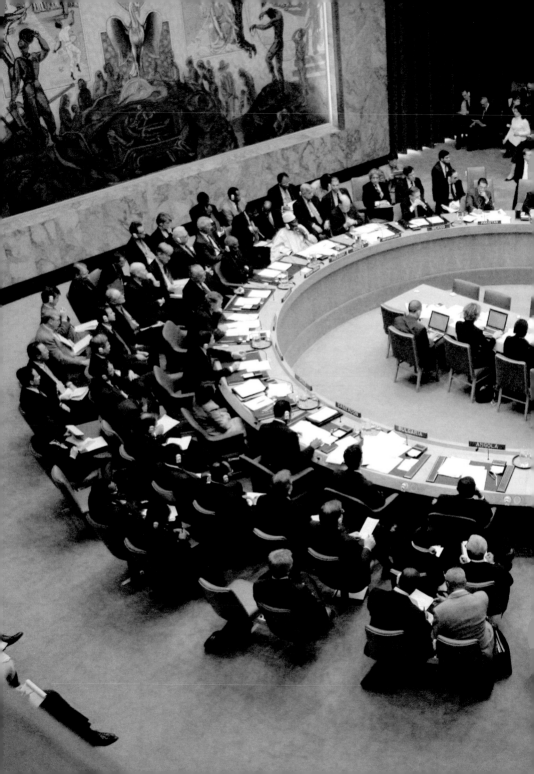

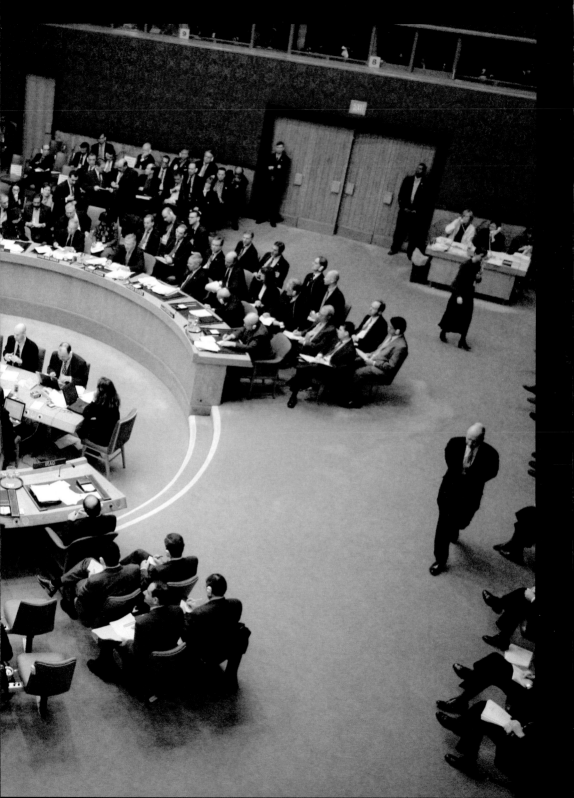

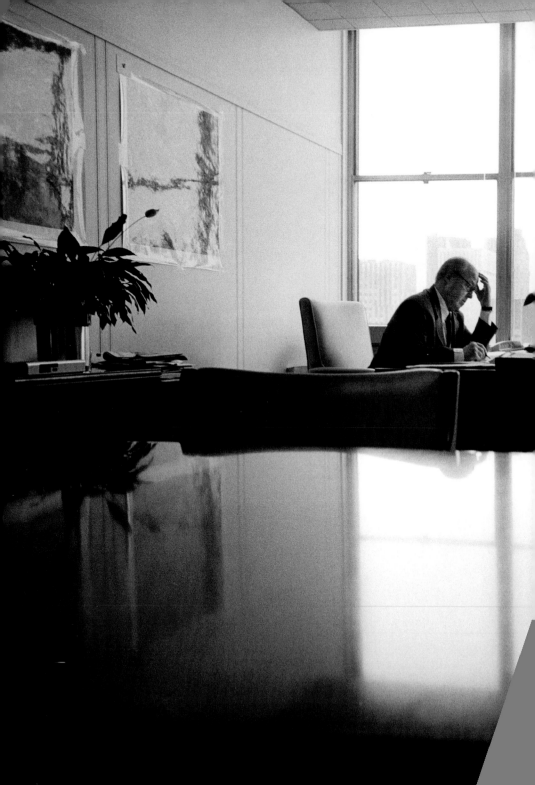

Chief U.N. weapons inspector Dr. Hans Blix at the United Nations New York, New York February 19, 2003

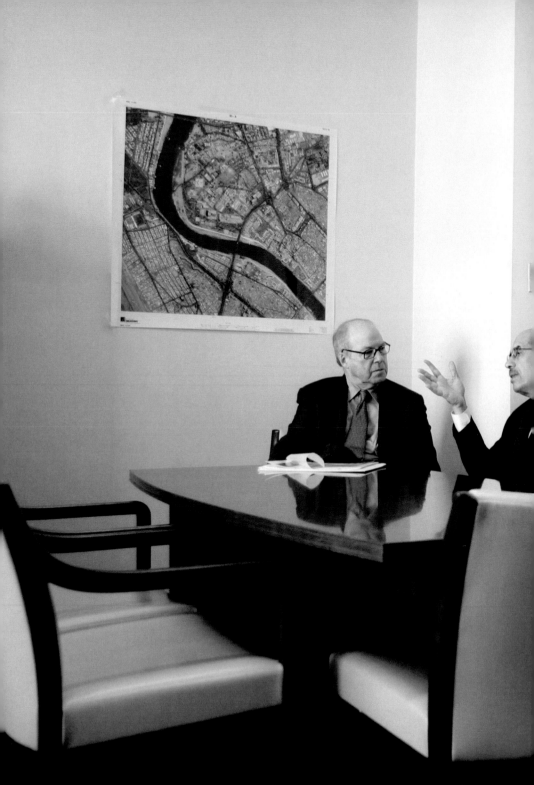

Chief U.N. weapons inspector Dr. Hans Blix with Dr. Mohamed ElBaradei, the director of the International Atomic Energy

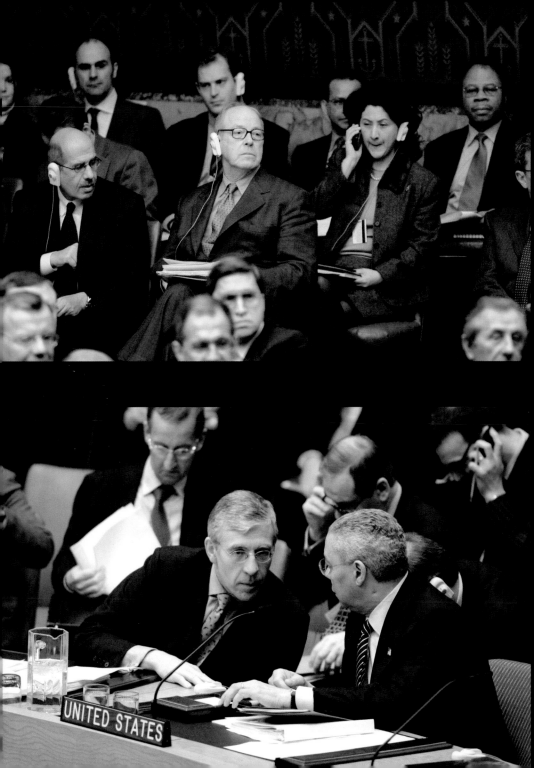

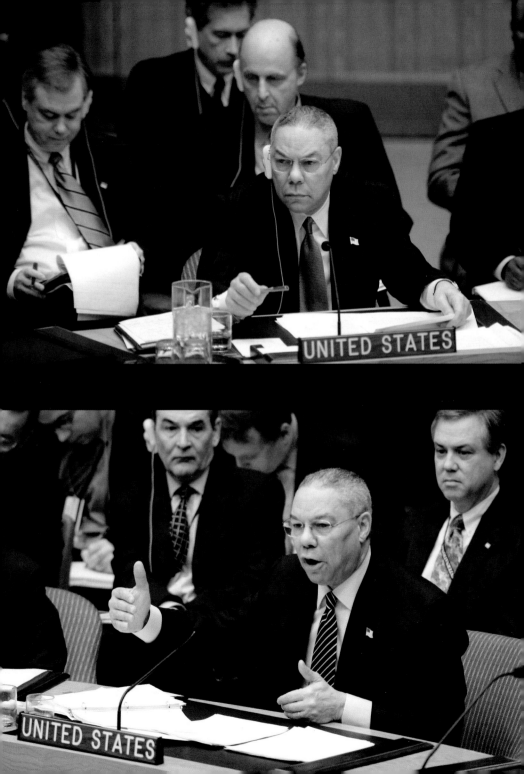

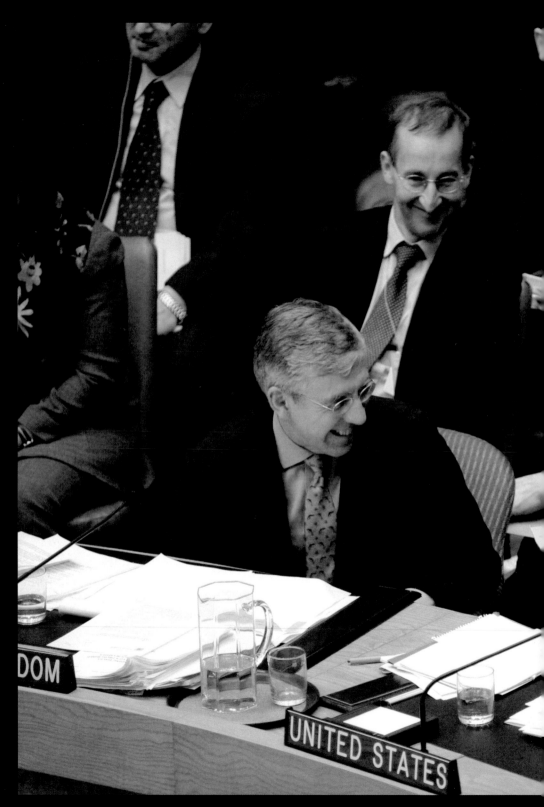

British Foreign Minister Jack Straw and U.S. Secretary of State Colin Powell at the U.N. Security Council.

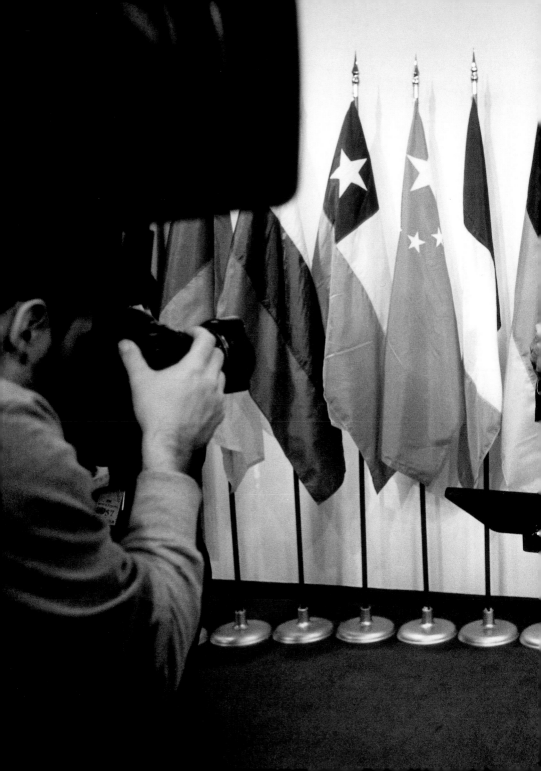

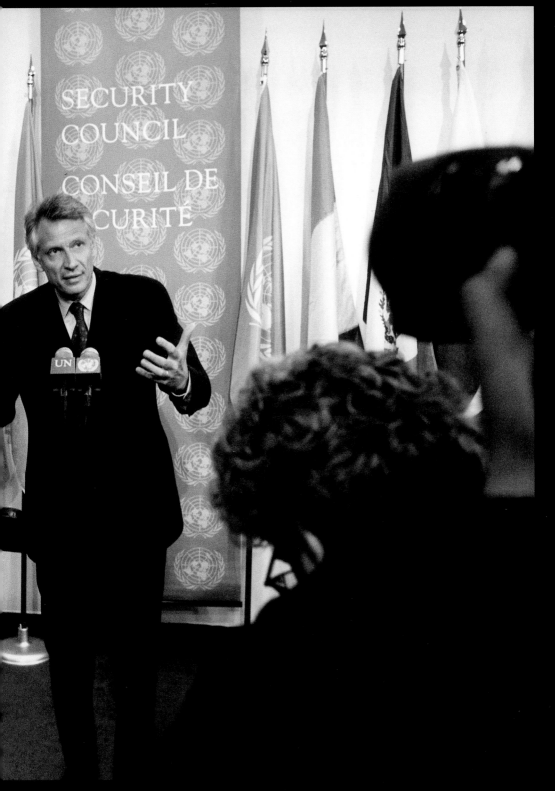

March 16, 2003

U.S., U.K., and Spanish leaders meet in the Azores to make a final attempt to obtain enough support among Security Council members to pass a new resolution for the use of force in Iraq. Nine sympathetic votes are needed.

At a news conference, President Bush makes clear his frustration with France's threat to veto a second resolution.

U.S. forces in the Gulf exceed 250,000 as both the U.S. and U.K. are said to be ready for a military assault.

March 17, 2003

The Security Council faces a deadline to agree on a new resolution demanding Iraqi President Saddam Hussein's immediate disarmament. U.S. President George W. Bush states that it is a "moment of truth for the world."

France says that it cannot accept a resolution authorizing the use of force. A Russian official echoes those comments saying that the current draft has "no chance" of being approved by the Security Council.

The U.N. vote is abandoned. The United States tells U.N. weapons inspectors to leave Iraq.

U.S. Secretary of State Colin Powell announces the end of diplomacy on the Iraq crisis.

Santa Maria, California
March 17, 2003

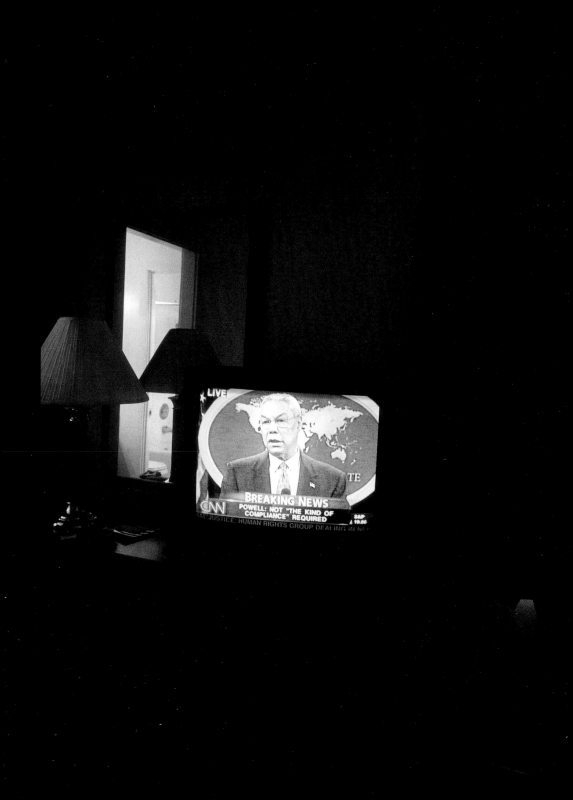

February 15, 2003

Millions across the United States, Europe, and Asia join in a global protest against the Bush administration's threat to invade Iraq. Anti-war rallies take place in up to 350 cities and 60 countries.

Estimates place the New York protest at 250,000, sometimes overflowing onto streets not permitted for the march. In an attempt to confine the demonstration, police charge horses into the crowds and make 295 arrests. Similar demonstrations take place in Philadelphia, Chicago, Seattle, San Diego, Sacramento, Miami, Detroit, Milwaukee, and numerous other American cities.

In London, 500,000 to 750,000 people rally in Hyde Park, while 200,000 gather at the Brandenburg Gate in Berlin. Hundreds of thousands also protest in Paris, Amsterdam, Brussels, Barcelona, Rome, Melbourne, Cape Town, Johannesburg, Auckland, Seoul, Tokyo, and Manila.

Protesters come from a wide-ranging political spectrum: college students, middle-aged couples, families with small children, older people who had marched for civil rights, and groups representing labor, environmental, religious, business, and civic organizations.

Speakers denounce President Bush's rush to war, while offering no sympathy for Iraq's dictator, Saddam Hussein. Bishop Tutu, the 71-year-old veteran of the peace movement, chanted. "Let America listen to the rest of the world and the rest of the world is saying, 'Give the inspectors time.'"

President Bush dismisses the anti-war protests, saying he will not make "policy based upon a focus group."

Streets

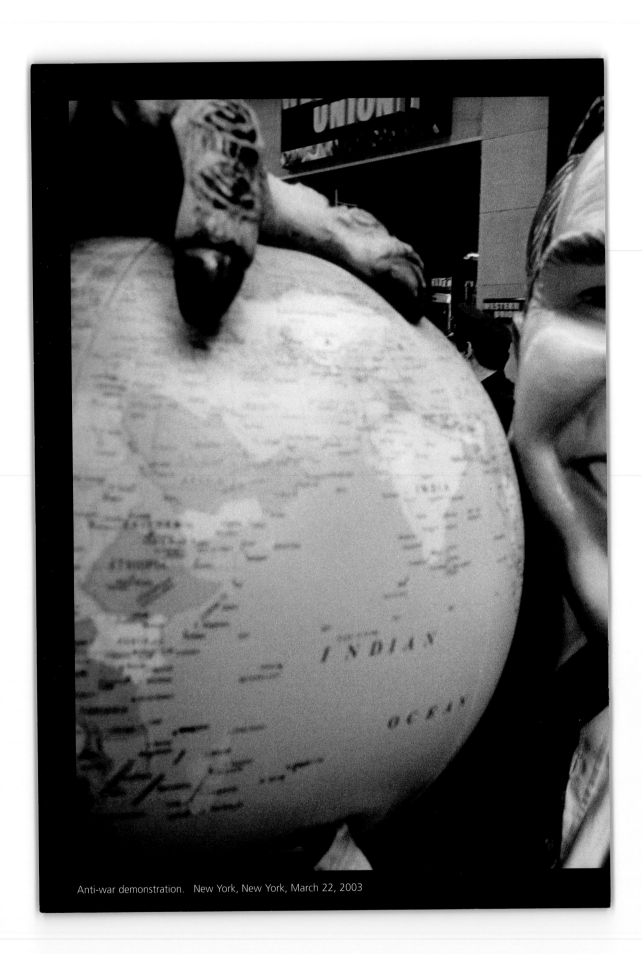

Anti-war demonstration. New York, New York, March 22, 2003

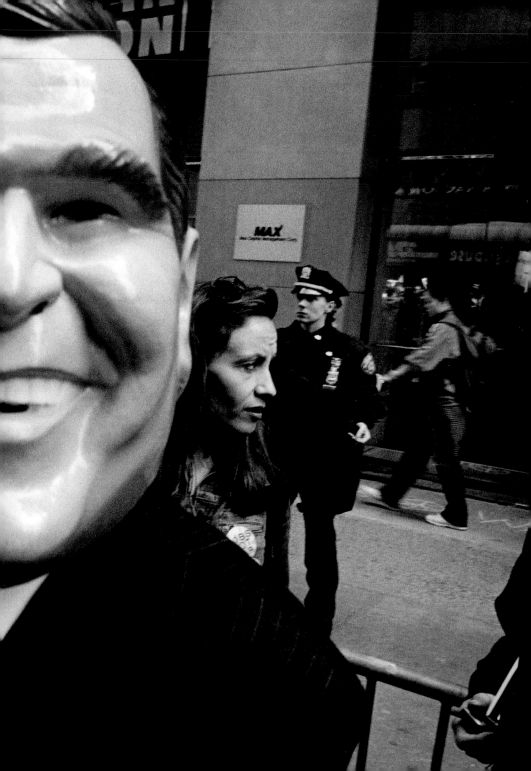

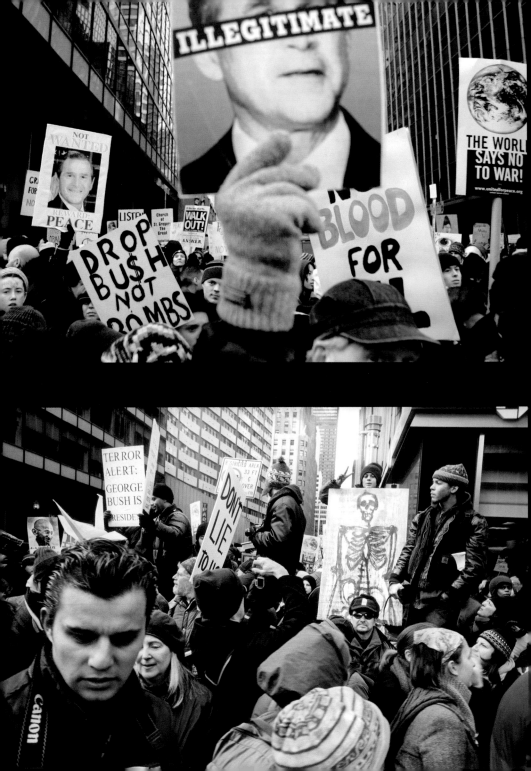

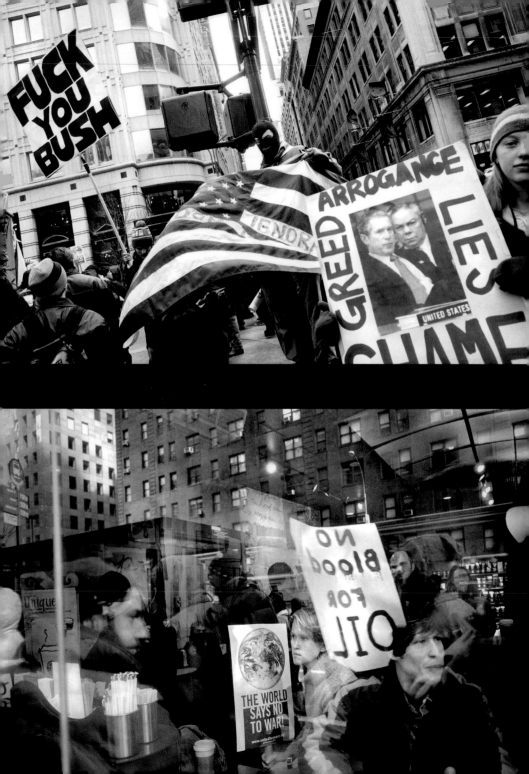

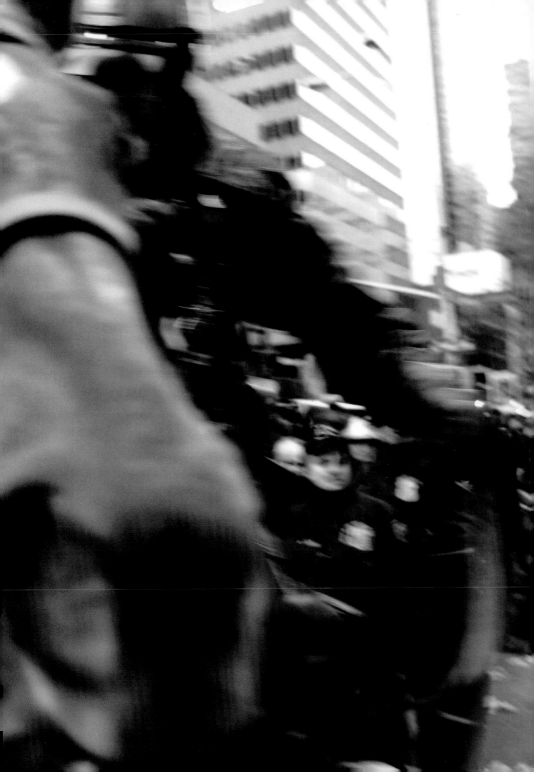

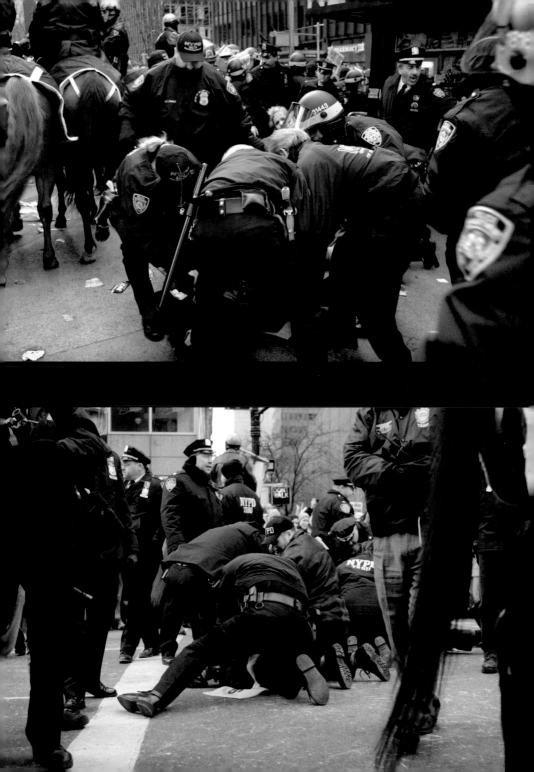

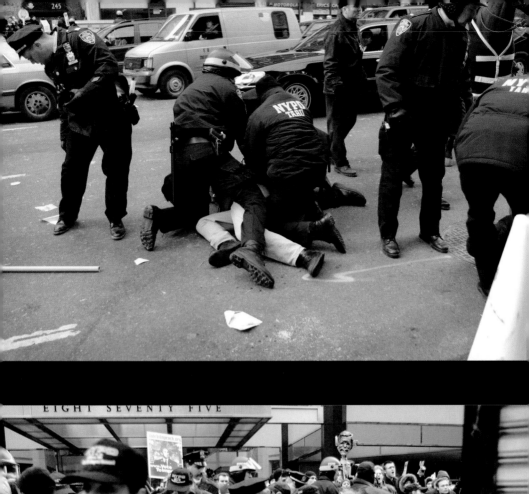

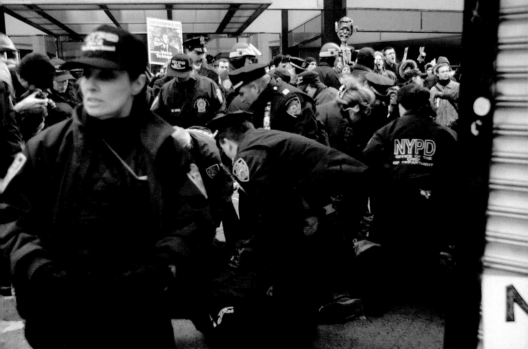

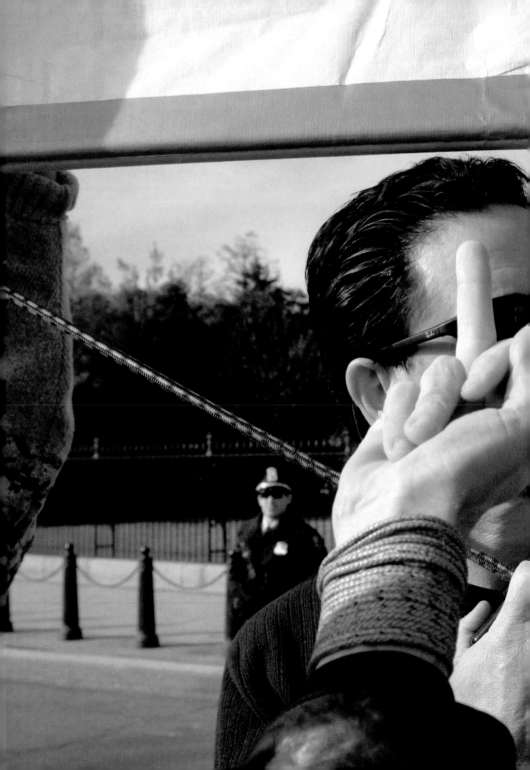

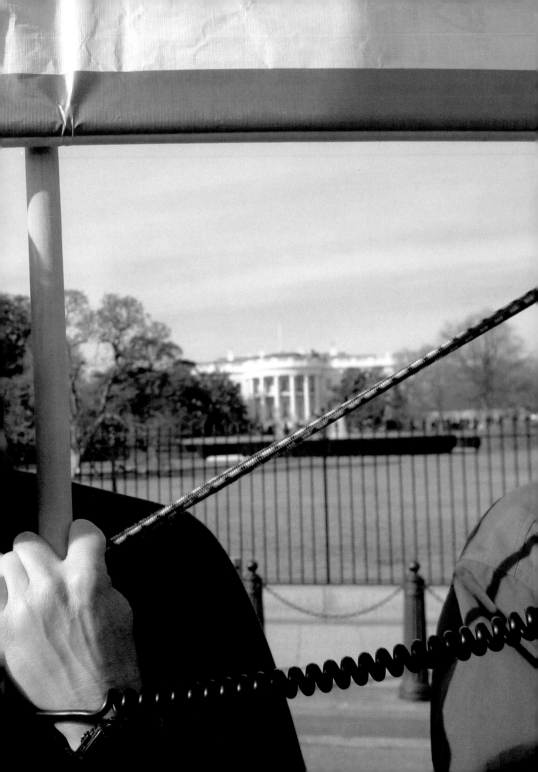

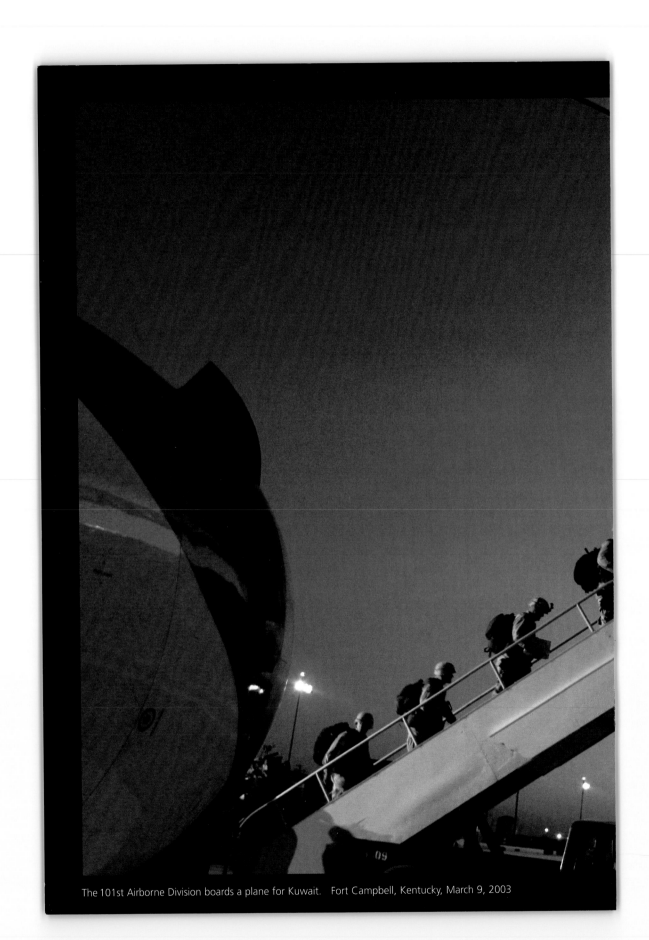

The 101st Airborne Division boards a plane for Kuwait. Fort Campbell, Kentucky, March 9, 2003

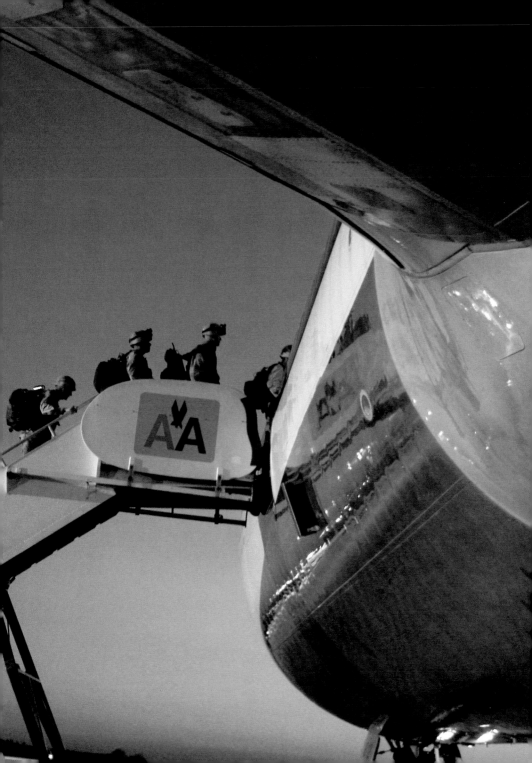

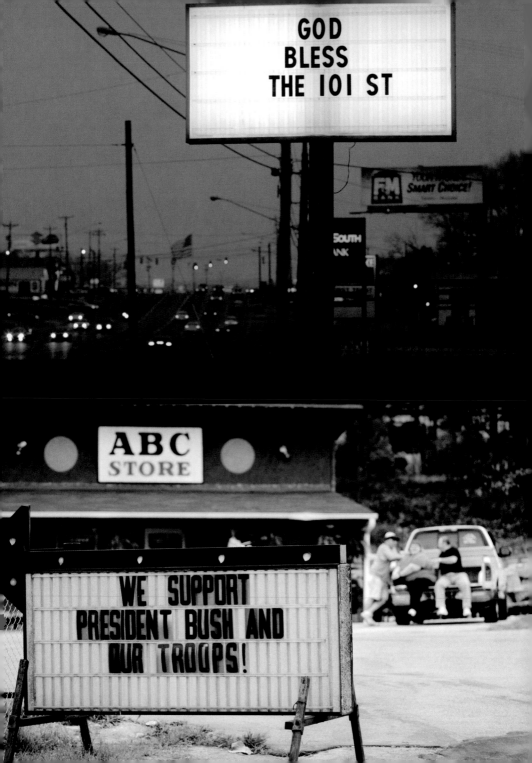

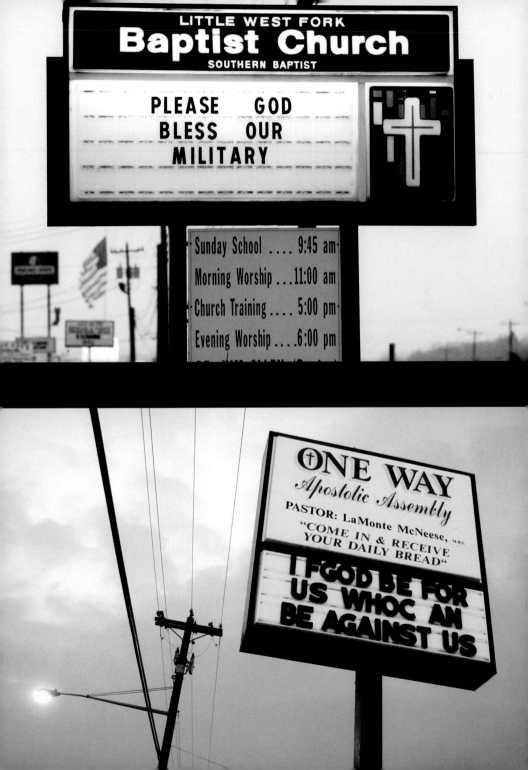

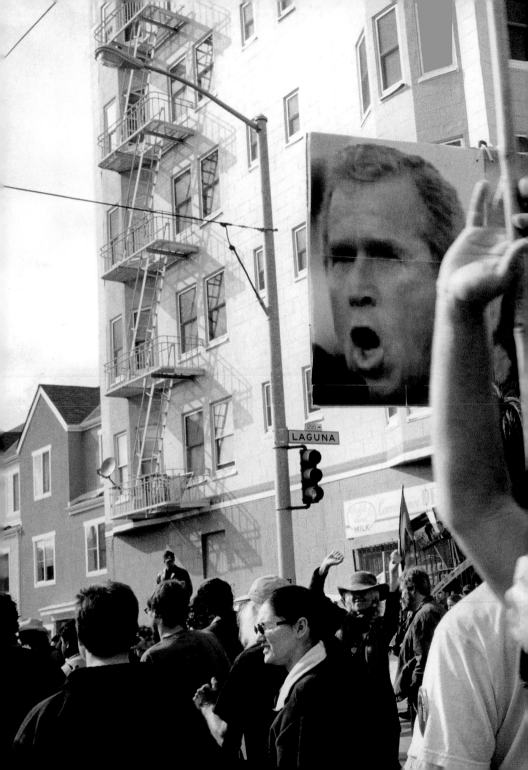

LAGUNA

MILK

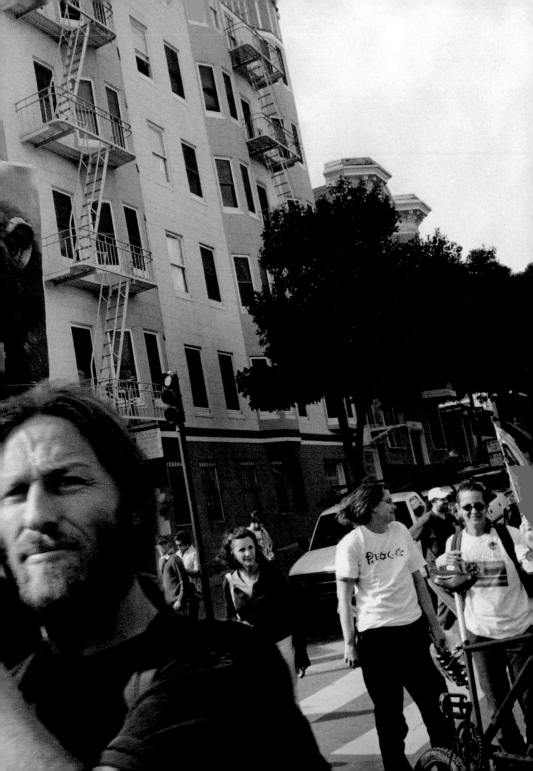

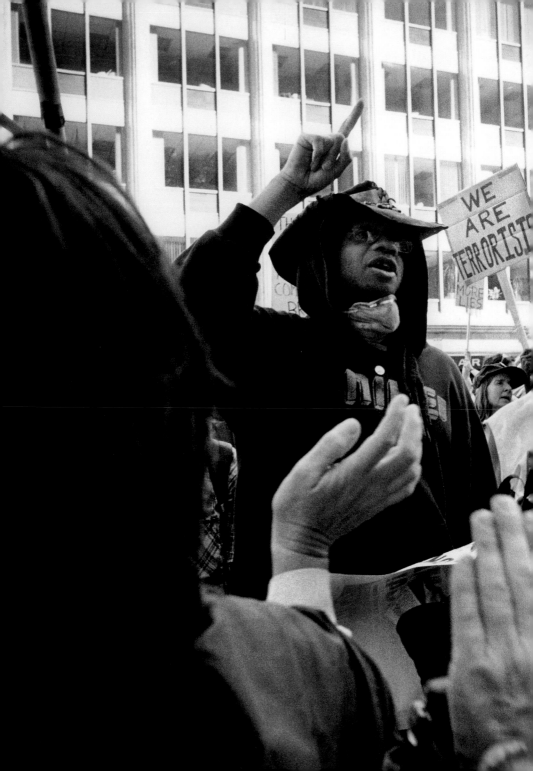

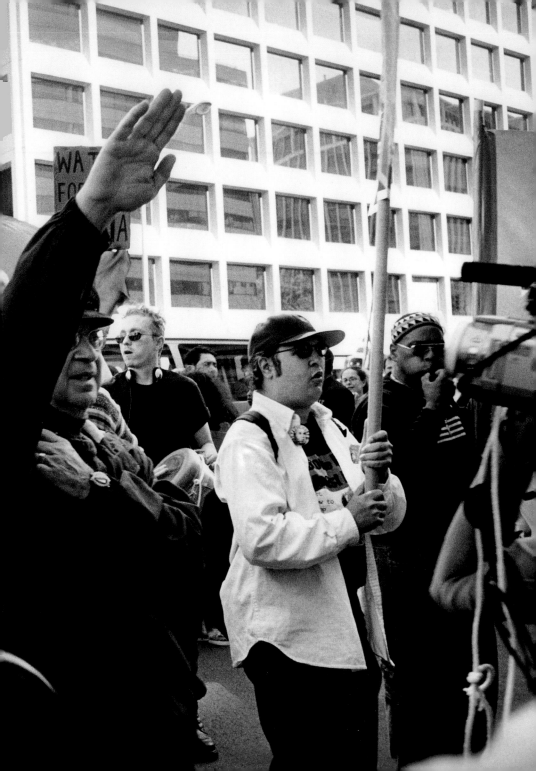

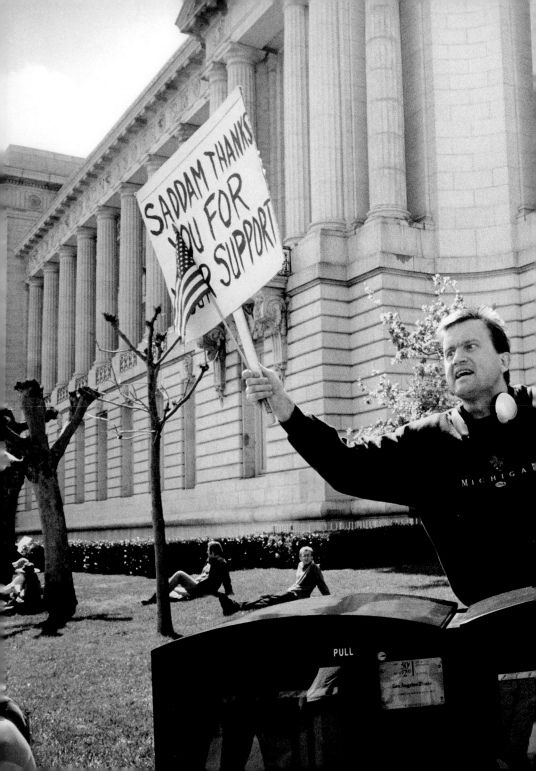

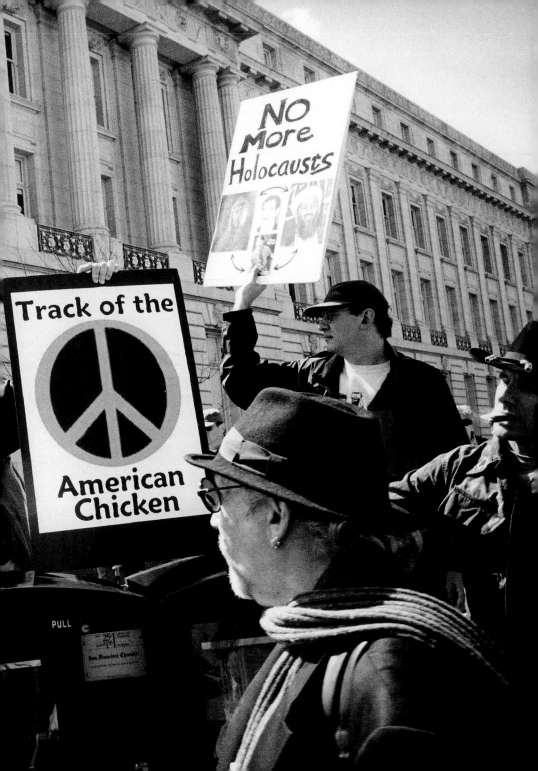

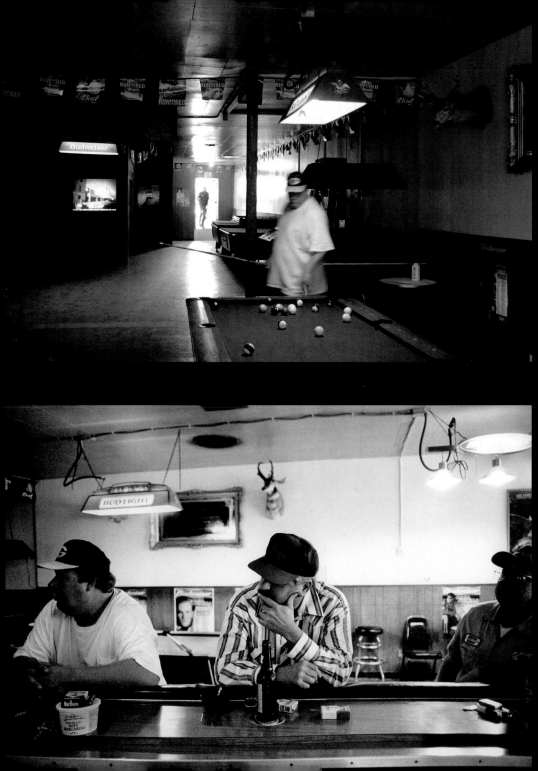

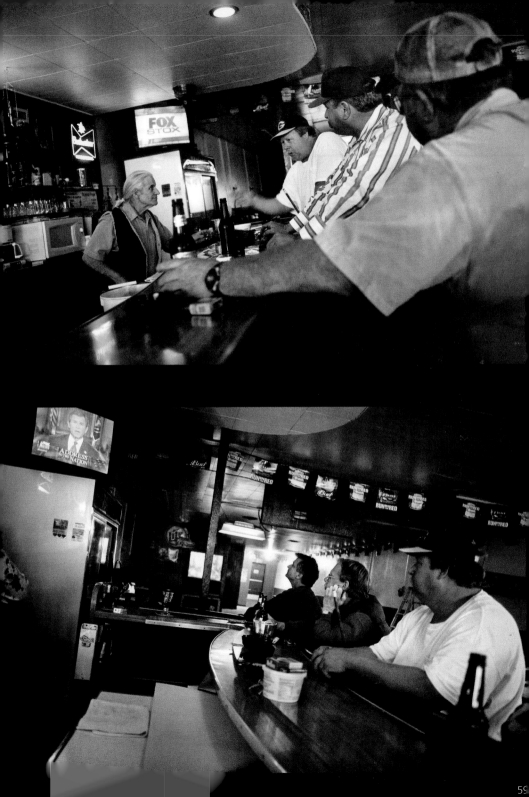

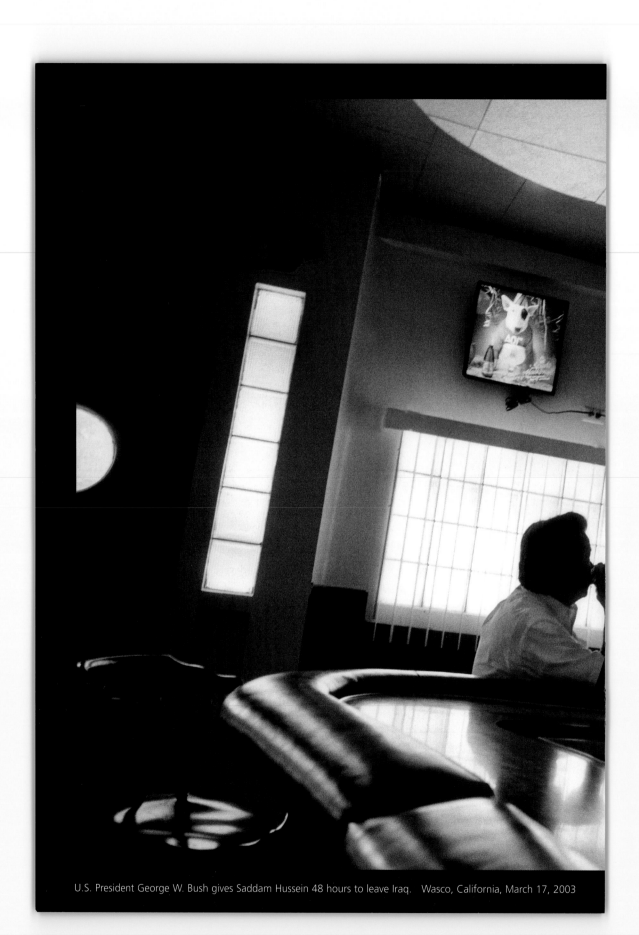

U.S. President George W. Bush gives Saddam Hussein 48 hours to leave Iraq. Wasco, California, March 17, 2003

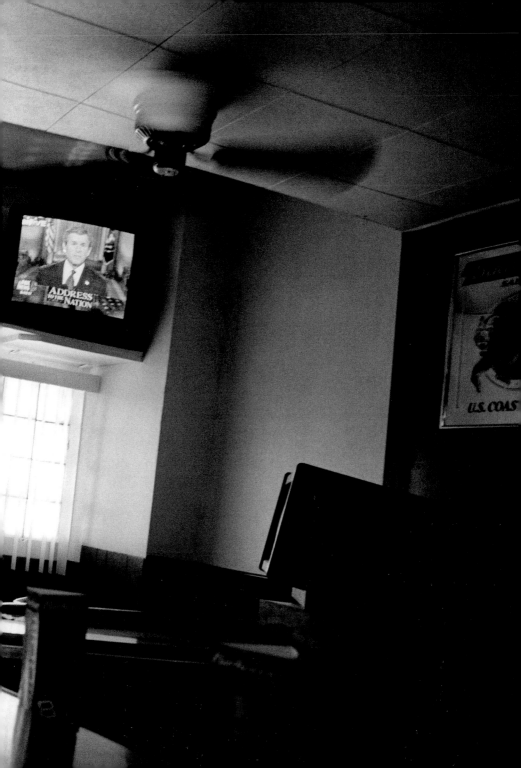

March 17, 2003

a live television address President Bush states, "Saddam Hussein and his sons must leave Iraq within 48 hours. Their refusal to do so will result in military conflict, commenced at the time of our choosing." The address is made hours after he had abandoned attempts to forge a united diplomatic front against Iraq.

Mr. Hussein shows no signs of complying.

The President places the United States on heightened alert for terrorist reprisals and prepares the American people for a war he said was an act of self-defense against a country that had es to terrorists and was still trying to amass, hide, and develop biological, chemical, and nuclear weapons.

War

March 19, 2003

U.S. President George W. Bush tells the nation the war has begun. "We will accept no outcome but victory," he says vowing to drive Iraqi President Saddam Hussein from power and eliminate the threat posed by the regime's weapons of mass destruction.

Images of explosions pounding Baghdad at dawn illuminate Times Square, while most Americans witness the bombing from their televisions at home, or in public spaces.

March 20, 2003

San Francisco police arrest 1,025 people during an anti-war demonstration. Protesters block the streets leading from the city's Oakland Bay Bridge and close down large sections of the city.

Tens of thousands of people join in demonstrations across the United States.

Huge protests erupt around the world, with violence in several countries including Belgium, Egypt, Spain, India, and Switzerland.

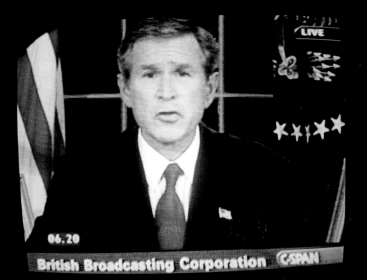

U.S. President George W. Bush declares war on Iraq.
San Francisco, California
March 19, 2003

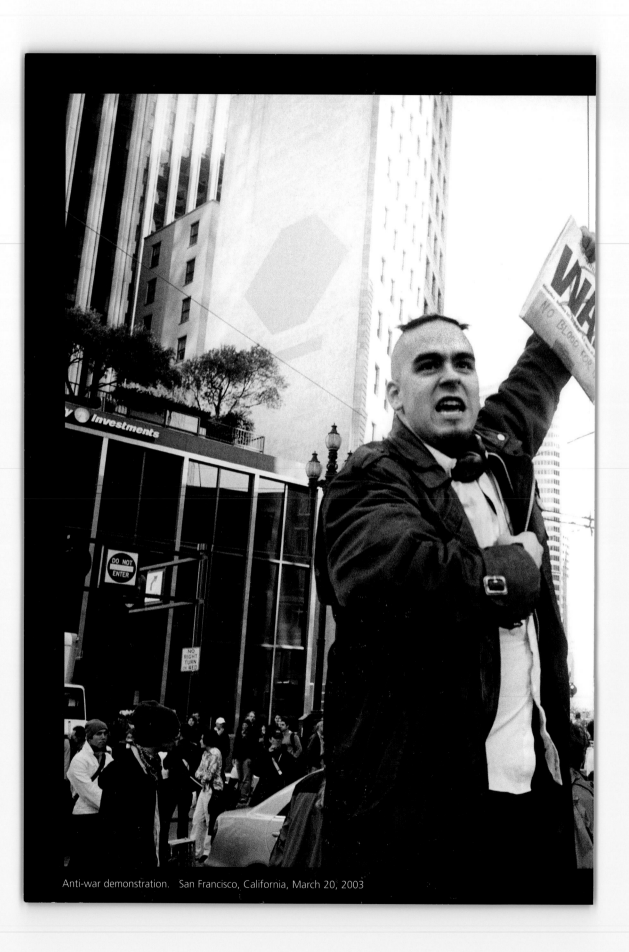

Anti-war demonstration. San Francisco, California, March 20, 2003

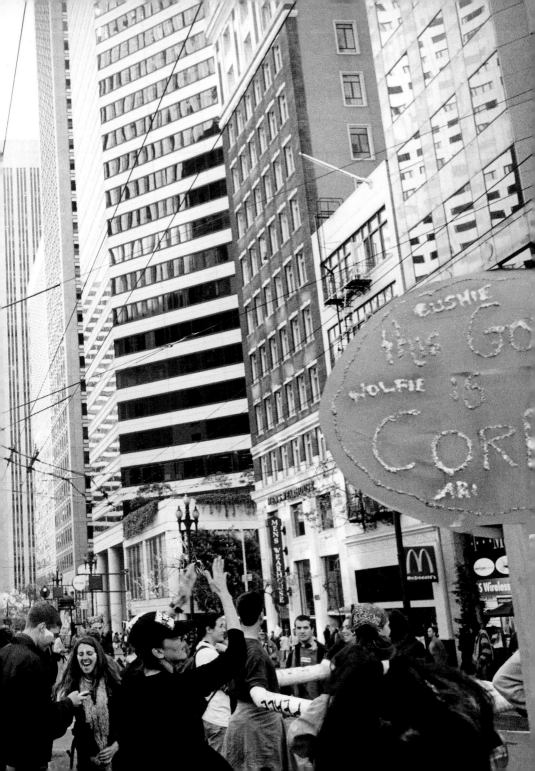

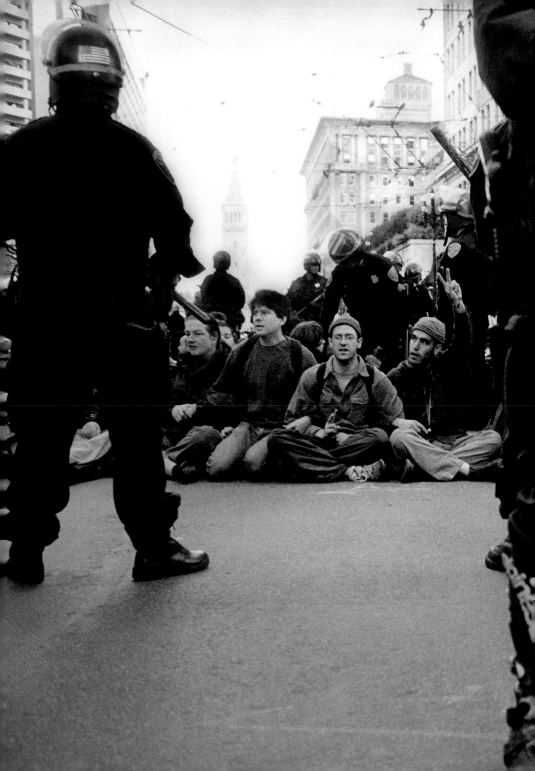

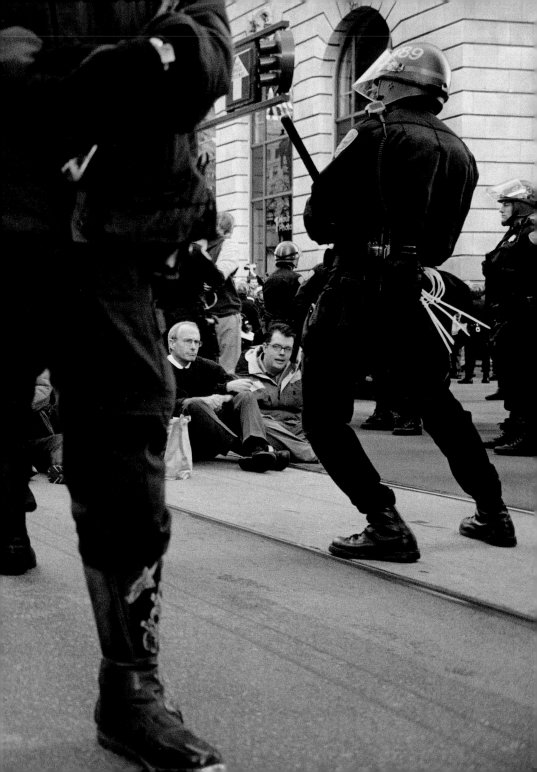

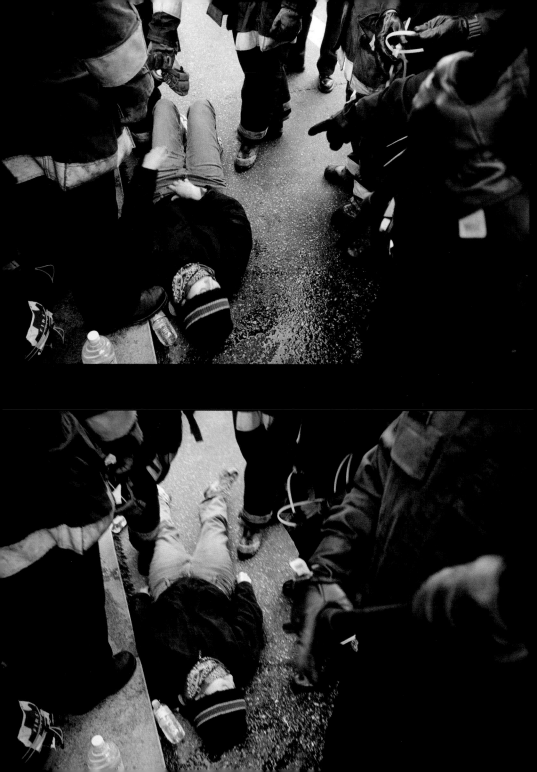

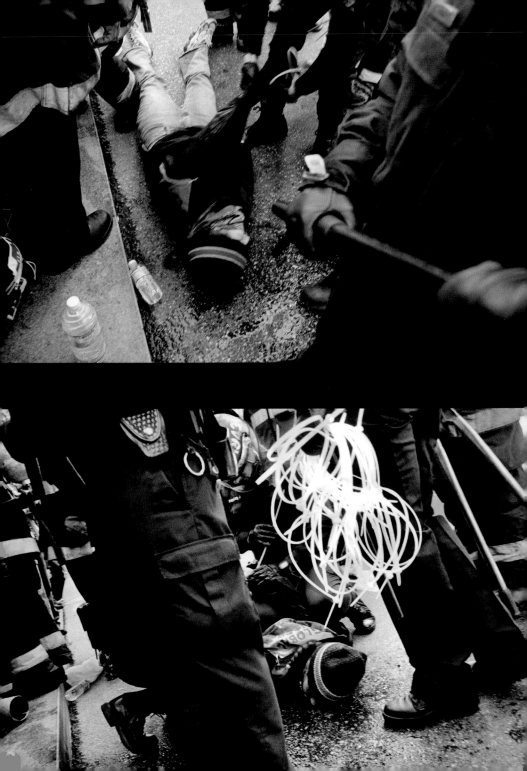

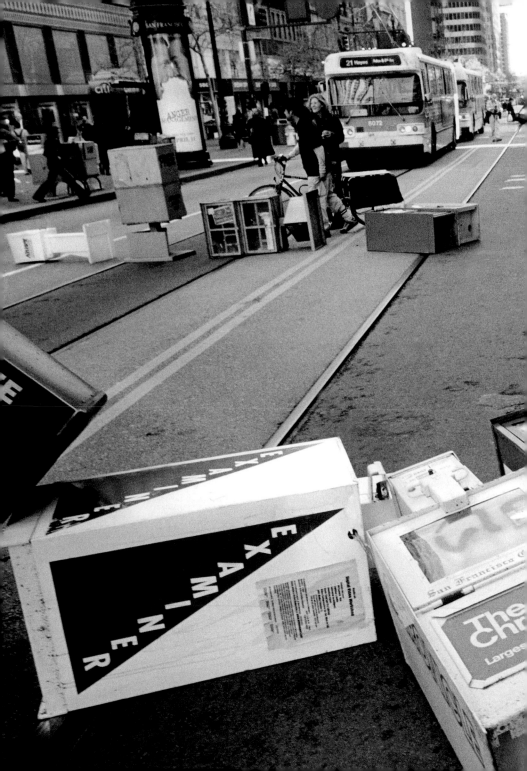

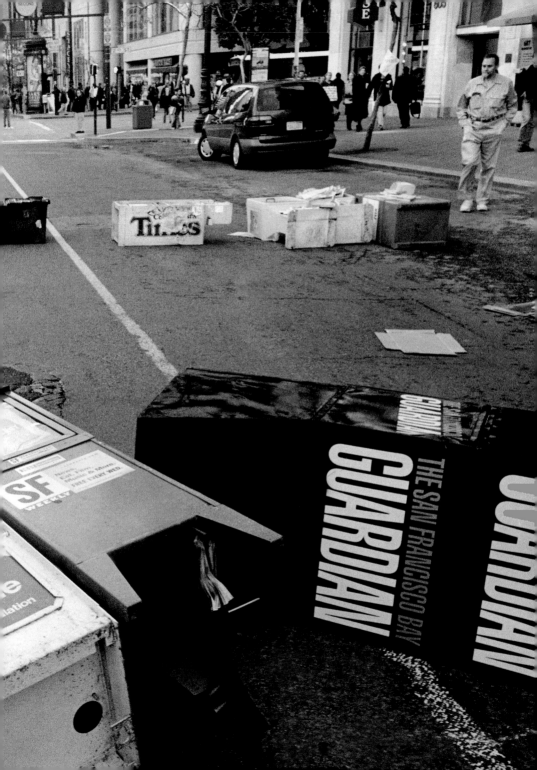

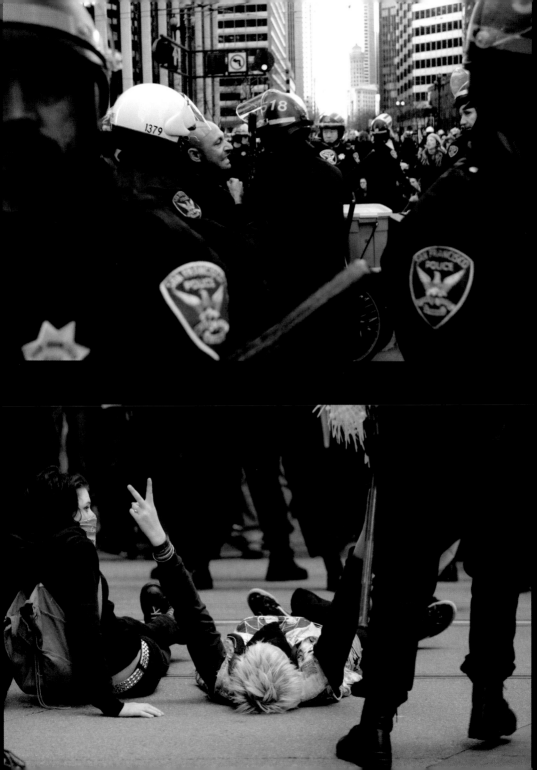

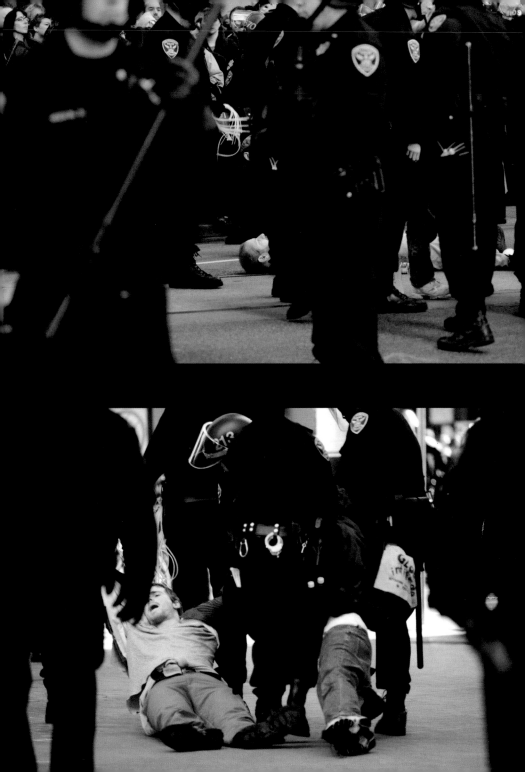

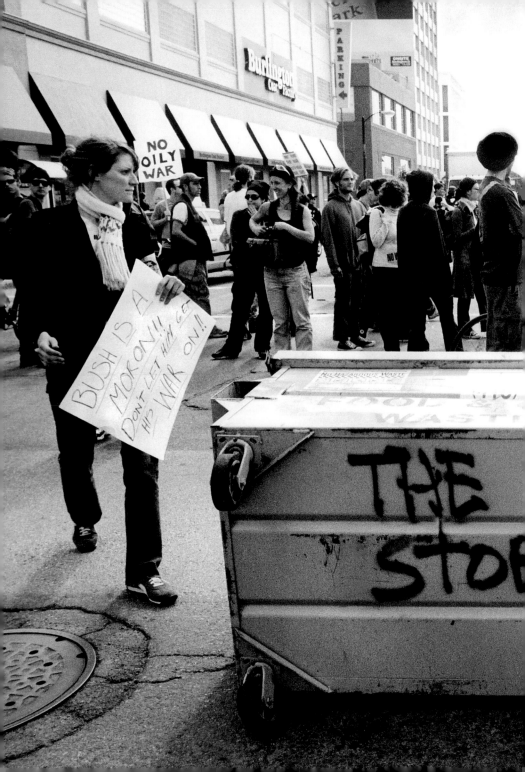

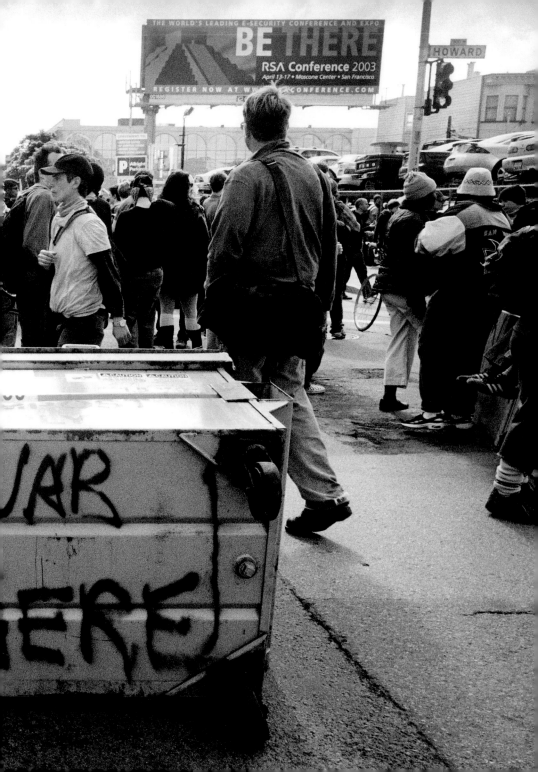

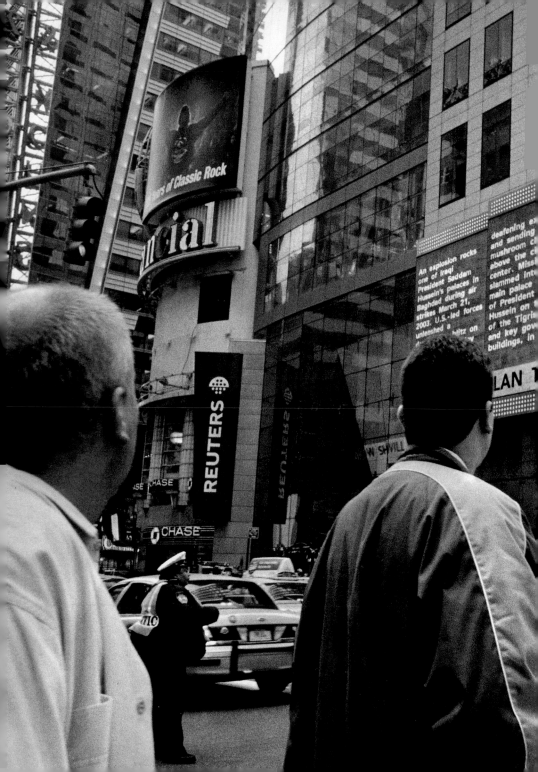

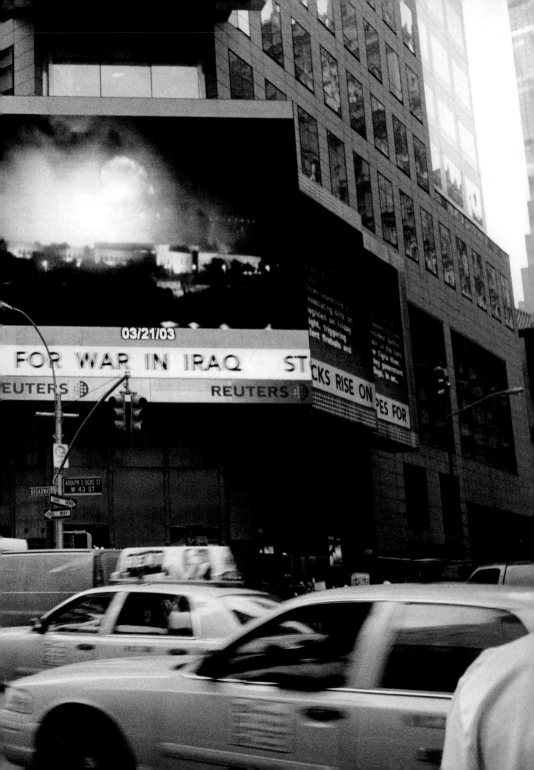

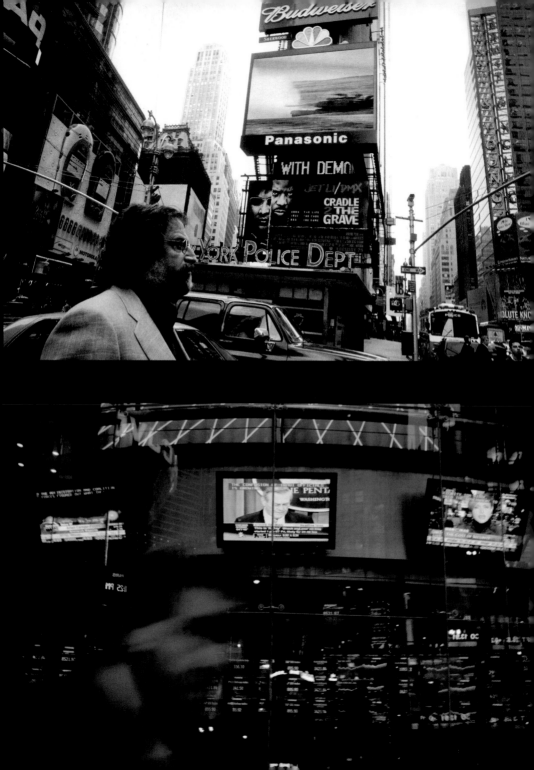

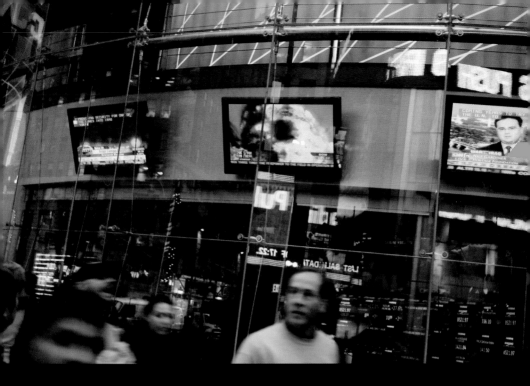

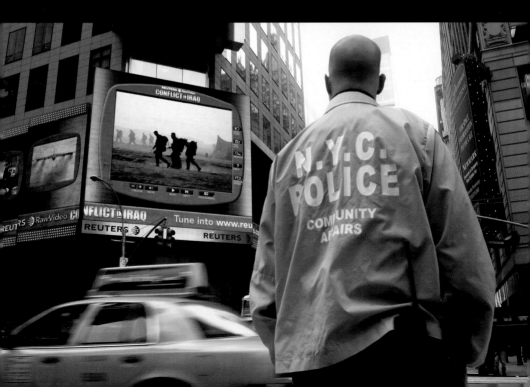

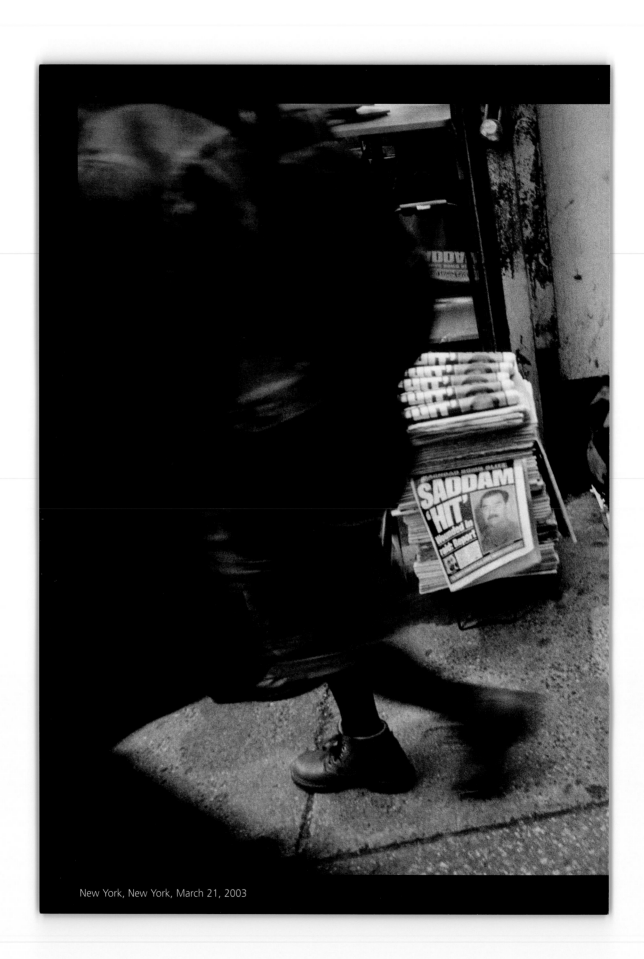

New York, New York, March 21, 2003

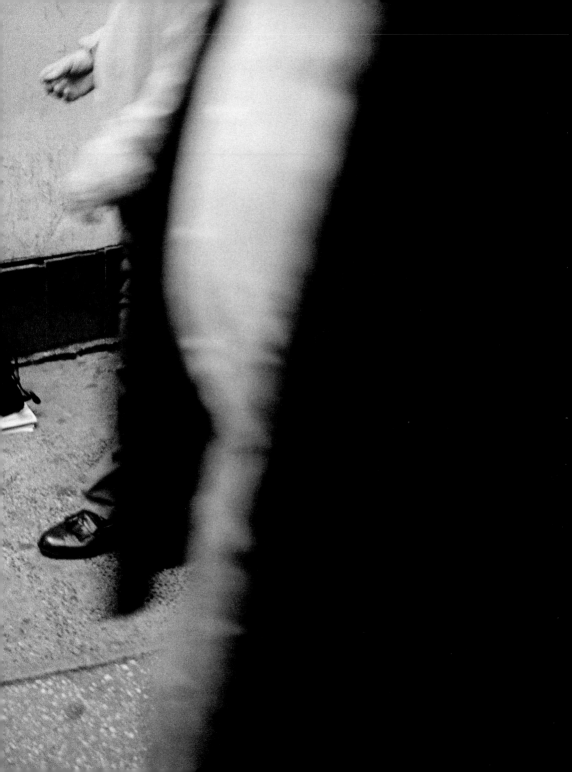

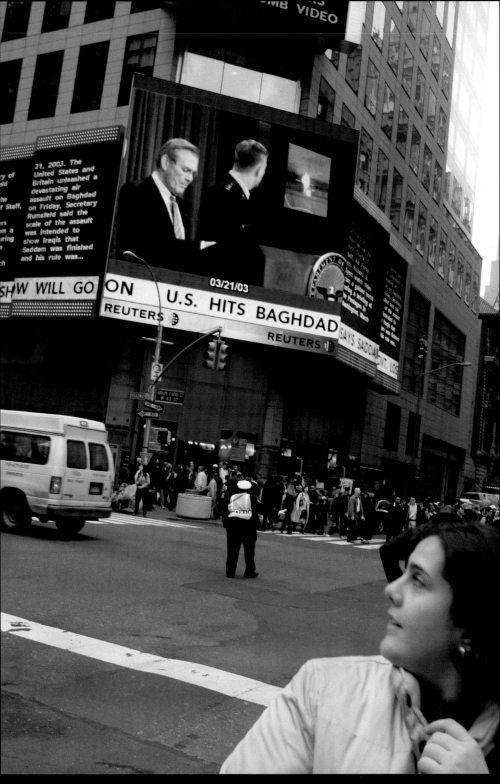

New York, New York, March 21, 2003

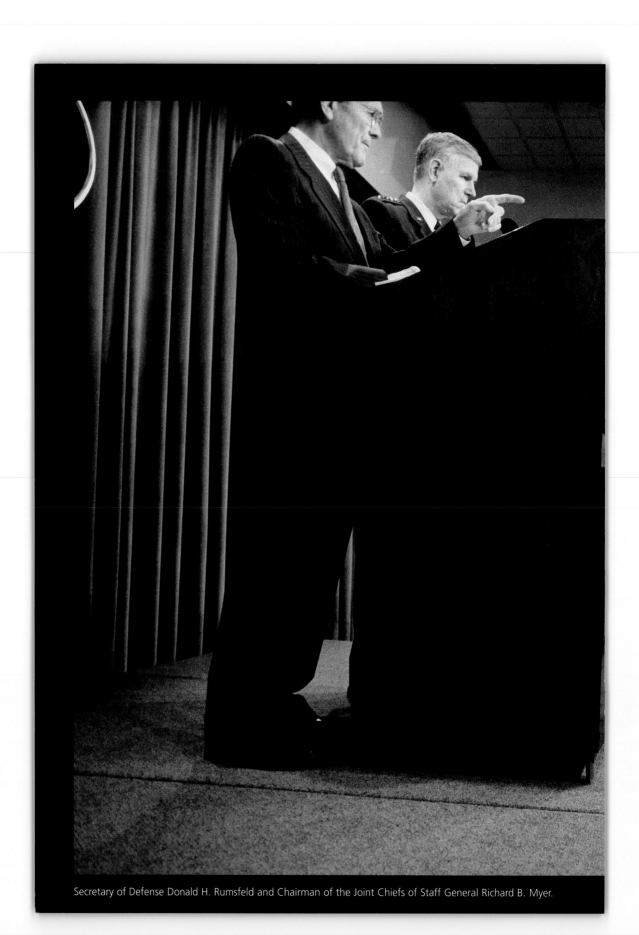

Secretary of Defense Donald H. Rumsfeld and Chairman of the Joint Chiefs of Staff General Richard B. Myer.

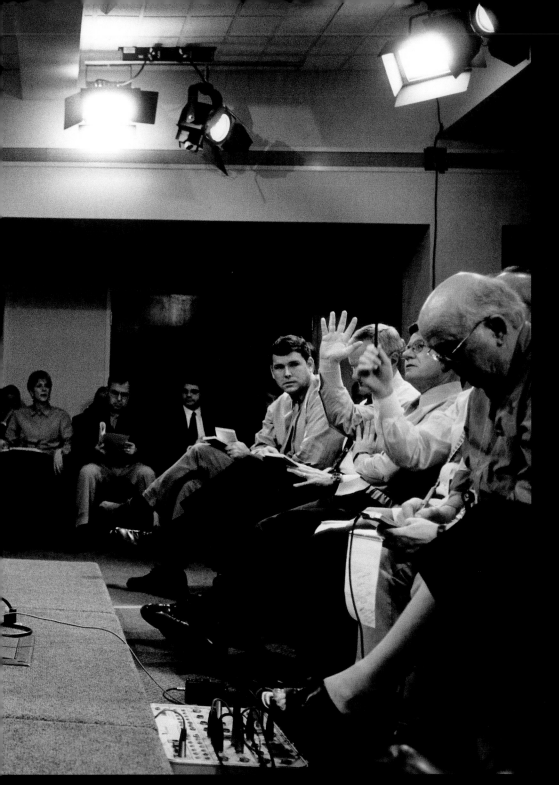

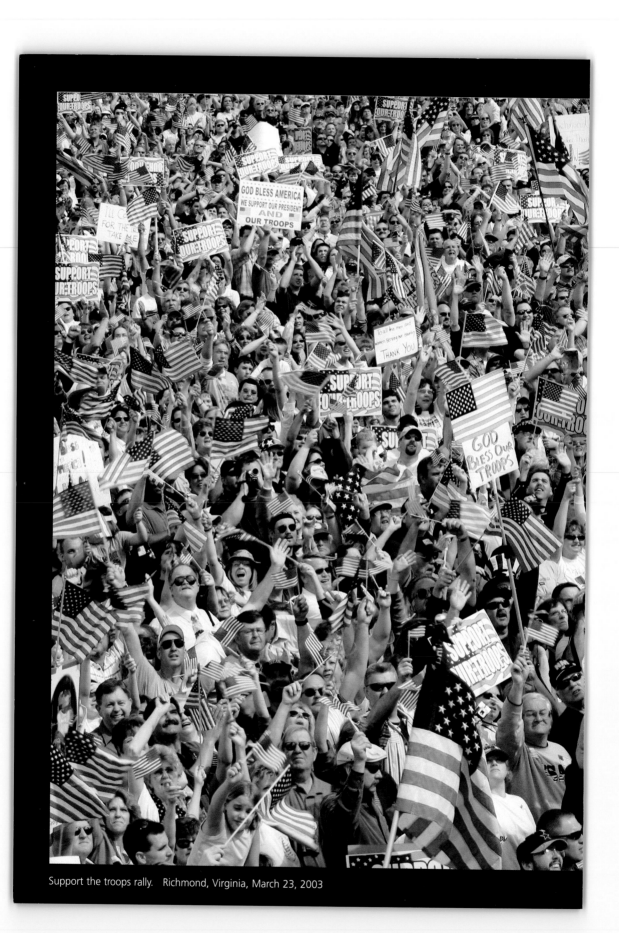

Support the troops rally. Richmond, Virginia, March 23, 2003

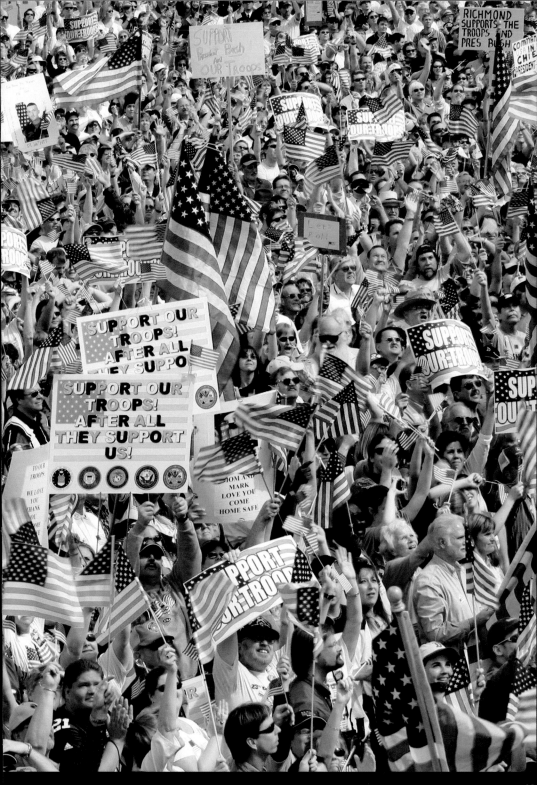

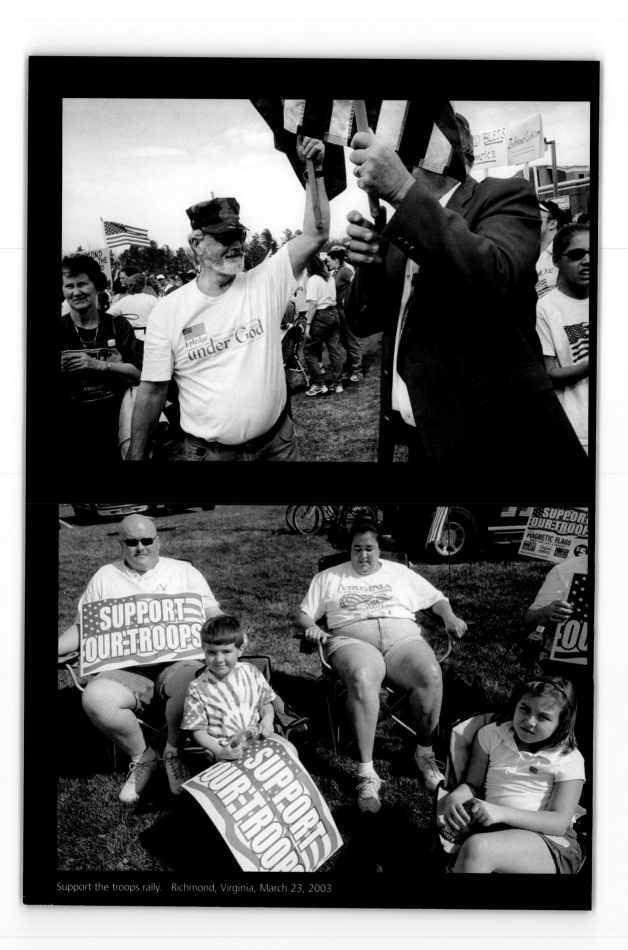

Support the troops rally. Richmond, Virginia, March 23, 2003

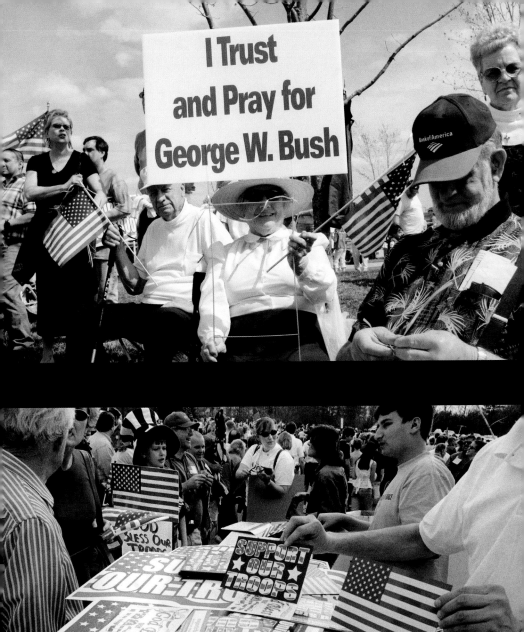

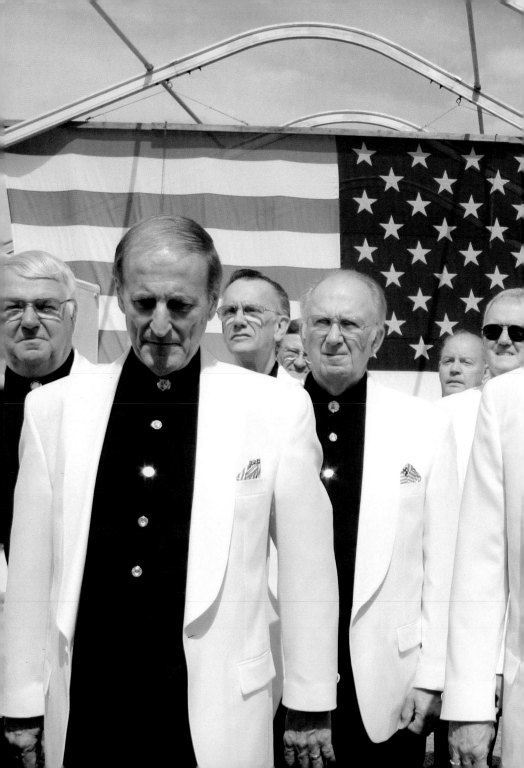

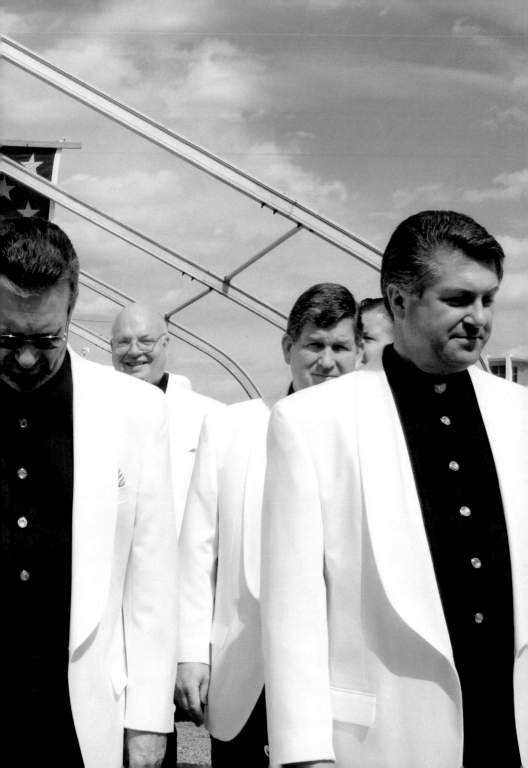

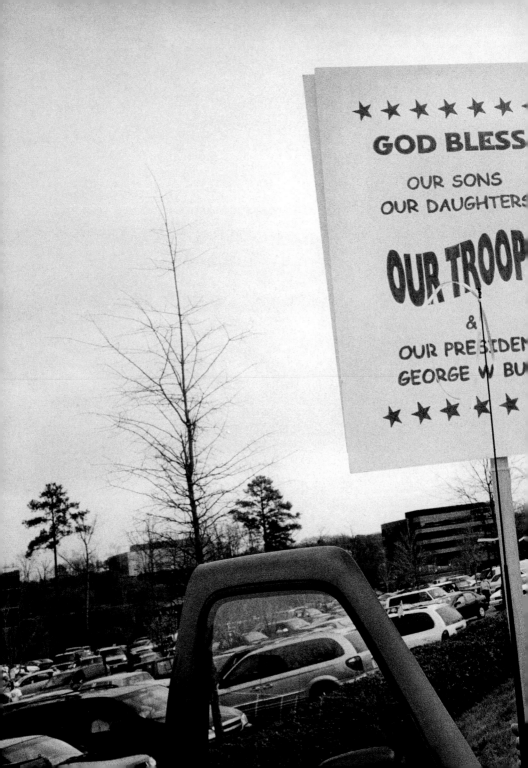

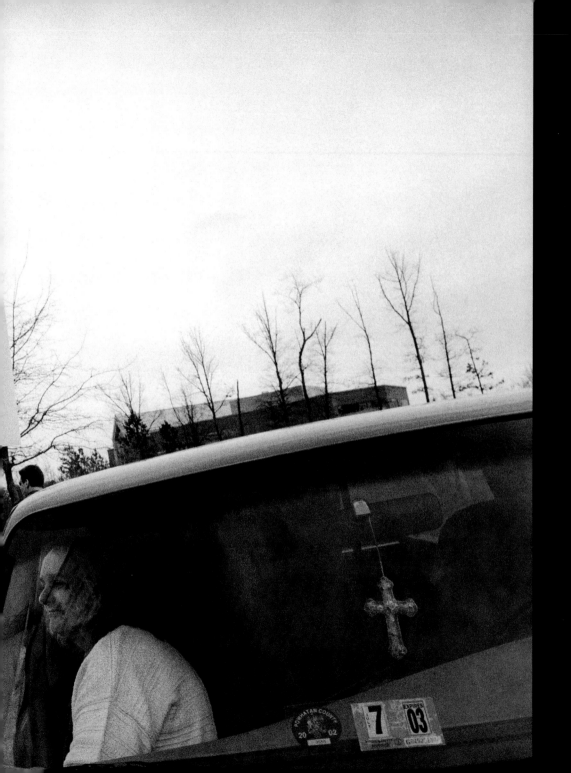

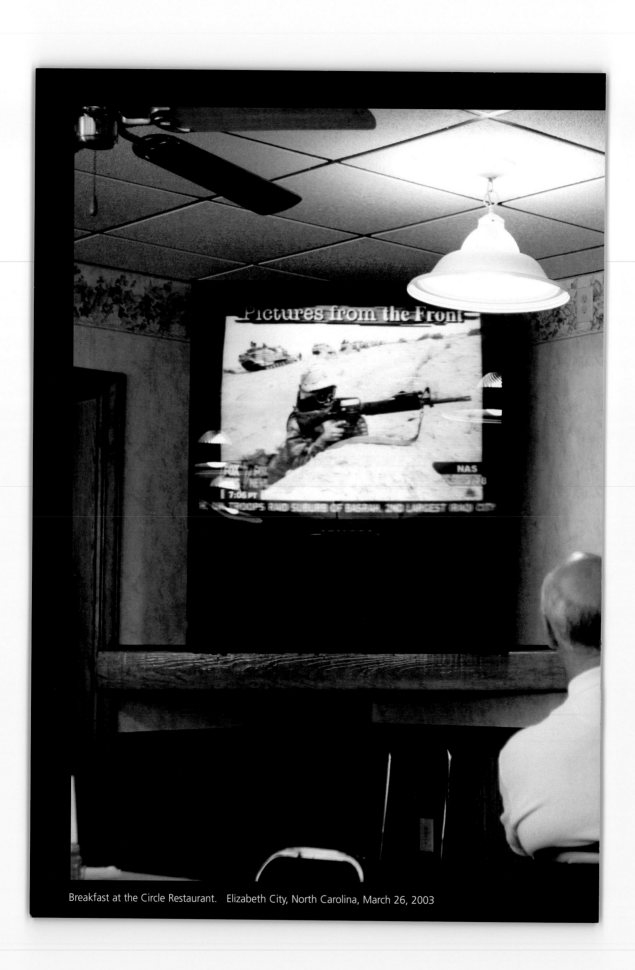

Breakfast at the Circle Restaurant. Elizabeth City, North Carolina, March 26, 2003

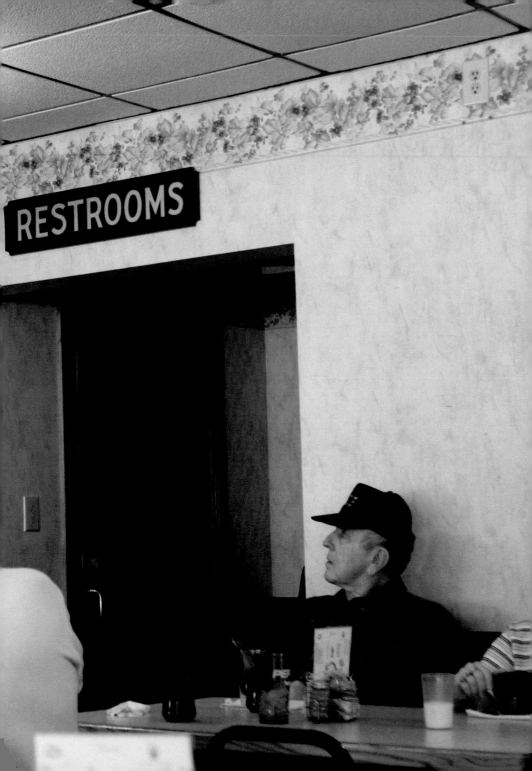

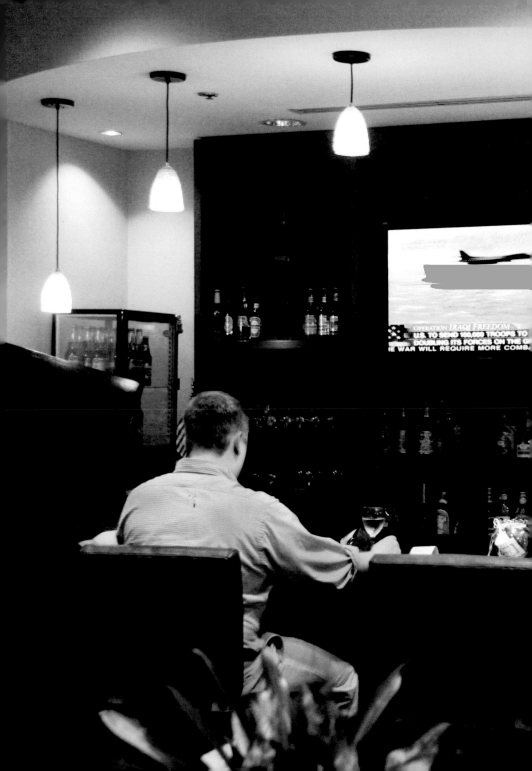

OPERATION *IRAQI FREEDOM*
U.S. TO SEND 100,000 TROOPS TO
DOUBLING ITS FORCES ON THE G
E WAR WILL REQUIRE MORE COMBA

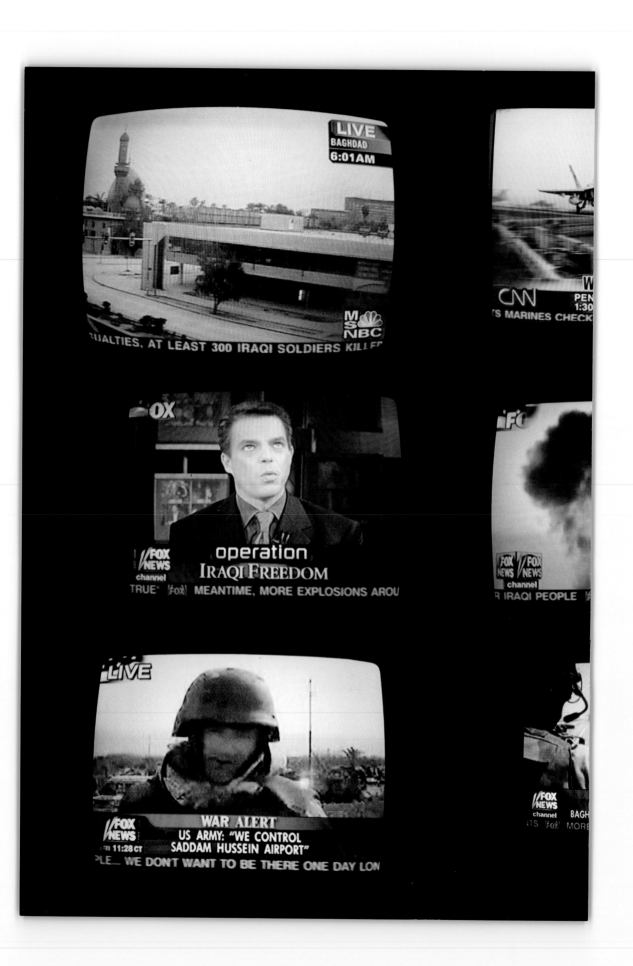

AQ ay
EFING DOW
LIVE ▲ 13.31
LE BREACH OF MEI

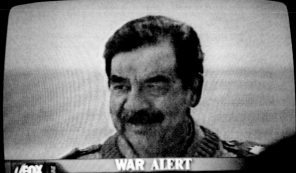

WAR ALERT
US ARMY: "WE CONTROL
SADDAM HUSSEIN AIRPORT"
12:37 ET
OPS TAKE AIRPORT AFTER BATTLE THAT LASTS MC

EFS OF STAFF GEN F

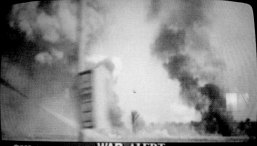

WAR ALERT
EXCLUSIVE: 3RD ID INSIDE
12:38 ET BAGHDAD -- VIDEO FROM ROAD-IN
FOX OFFICIALS SAY ISSUE OF SECURITY IS THE

ERT
ID INSIDE
ROM ROAD-IN
ROCK BAGHDAD... TH

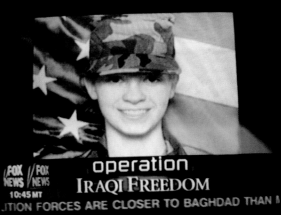

operation
IRAQI FREEDOM
10:45 MT
ITION FORCES ARE CLOSER TO BAGHDAD THAN I

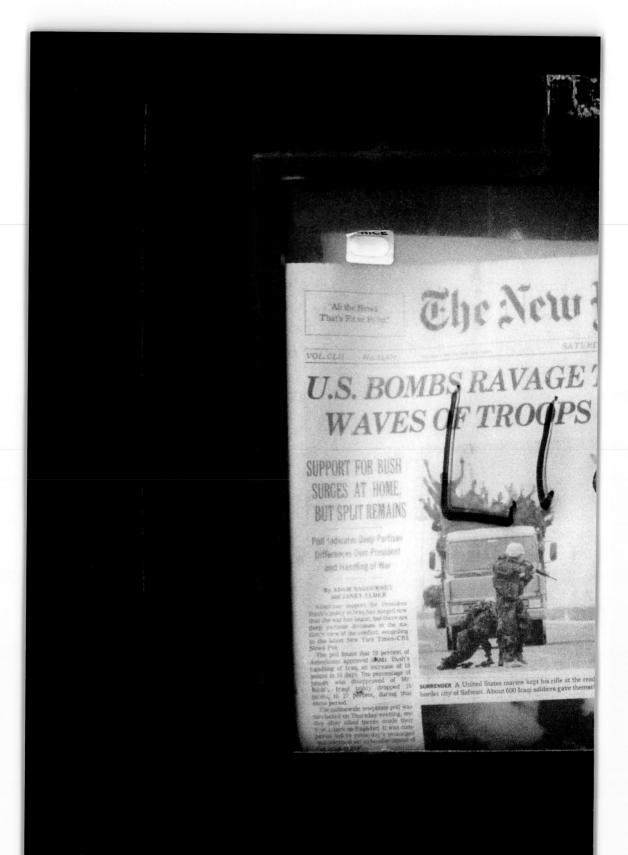

Madison, Wisconsin, April 5, 2003

k Times

GETS IN BAGHDAD; EPING SOUTH IRAQ

Surrenders by Iraqi Forces —
2 Marines Die in Fighting

By PATRICK E. TYLER

KUWAIT, March 2 — In a blitz of heavy bombing, American air power tonight pounded targets of Baghdad tonight, including central government buildings and palaces built by Saddam Hussein, as waves of fresh ground forces streamed into Iraq from the south.

The troops crossing the border from Kuwait to Iraq followed rapidly advancing armies whose vanguard of tanks had penetrated as much as 100 miles northward, about a third of the way to the capital, Baghdad.

Troops fanned out across southern Iraq to seize a port, strategic oil fields and refineries on an eastern flank near the city of Basra. To the west, Army and Marine units took control of air bases and cleared a wide path through the desert for the expected assault on Baghdad. [Map, Page B14.]

Two marines were killed in fighting today, one in a night of skirmishing to take the port of Umm Qasr and the other during a firefight at the Rumaila oil field. Their deaths followed the loss of four other marines and eight British marines in an early morning helicopter crash.

surrendered in a military prison company. Most of the division's soldiers had fled or "melted away," they said.

In the first significant surrender of Iraqi forces, 600 soldiers gave themselves up to fighting throughout the south, many of them around Umm Qasr and on the adjacent Fao peninsula, both now in allied hands. The Iraqi armed forces number about 390,000.

But the mass surrenders that followed the Iraqi military collapse in Kuwait in 1991 have not yet occurred this time, though American military officials said, without giving details, that they saw many signs of breakdown in the Iraqi military command.

In general, it was only week units of the Iraqi Army that remained in the southern part of the country, and American and British forces are expected to meet far stiffer resistance as they move north toward Baghdad.

In the north of Iraq, in the area controlled by Kurds, Turkey sent between 1,000 and 1,500 soldiers across the border today after Abdullah Gul, the Turkish foreign minister, said the troops were needed to control refugee flows.

Forty in deep concern in United

...endered near the southern ...ting throughout the south.

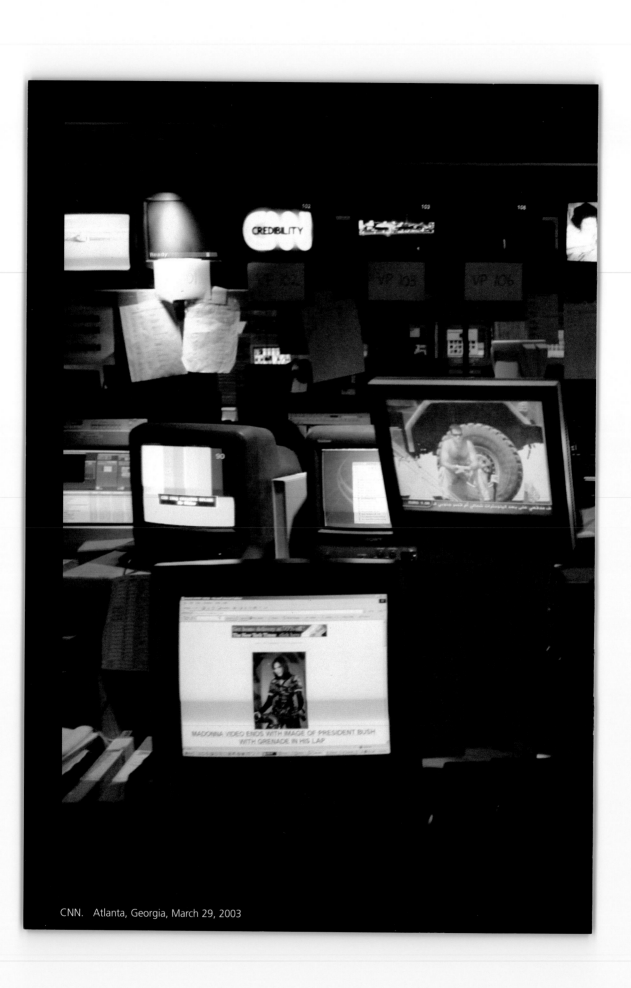

CNN. Atlanta, Georgia, March 29, 2003

CREDIBILITY

EMBED DESK

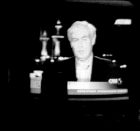

REDIBILITY

Ready

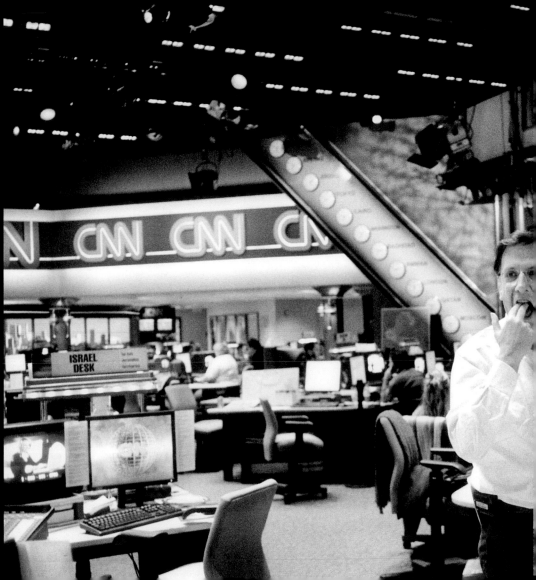

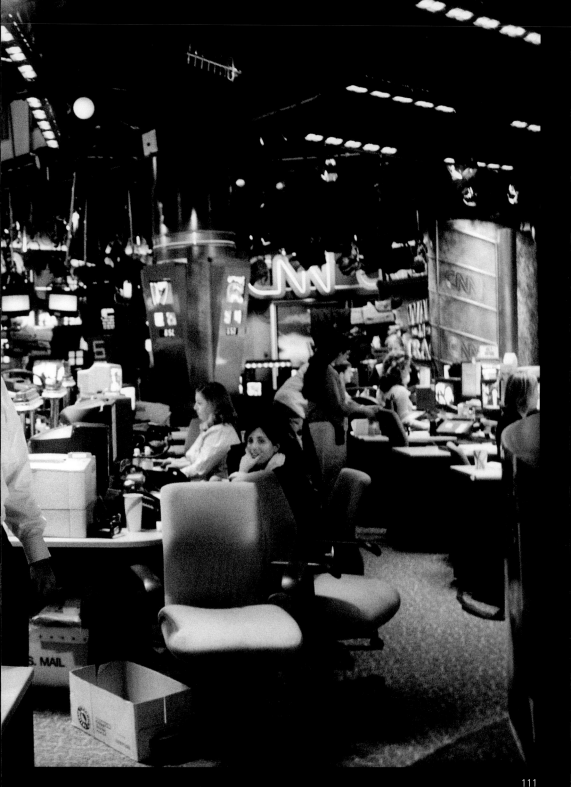

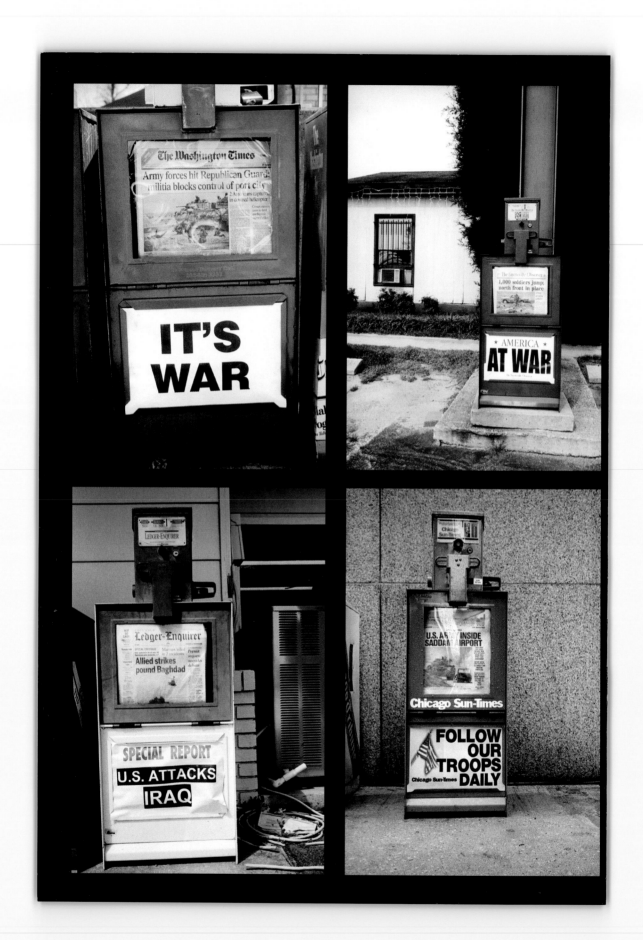

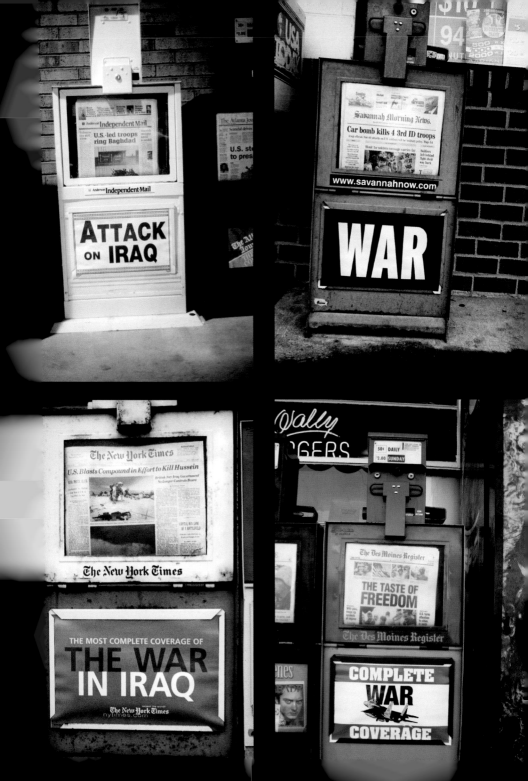

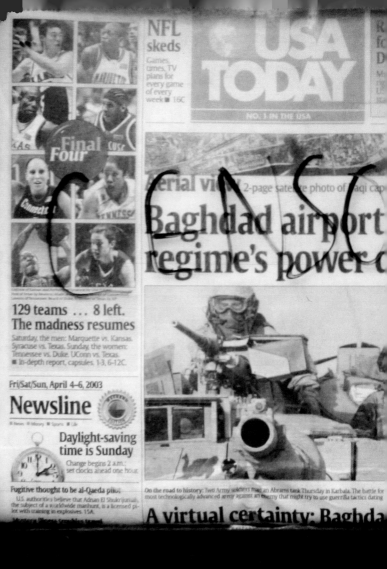

USA TODAY

NO. 1 IN THE USA

Aerial view 2-page satellite photo of Iraqi capital

Baghdad airport
regime's power c

129 teams ... 8 left.
The madness resumes

Saturday, the men: Marquette vs. Kansas.
Syracuse vs. Texas. Sunday, the women:
Tennessee vs. Duke. UConn vs. Texas.
■ In-depth report, capsules. 1-3, 6-12C.

Fri/Sat/Sun, April 4–6, 2003

Newsline

■ News ■ Money ■ Sports ■ Life

Daylight-saving
time is Sunday

Change begins 2 a.m.:
set clocks ahead one hour.

Fugitive thought to be al-Qaeda pilot

U.S. authorities believe that Adnan El Shukrijumah,
the subject of a worldwide manhunt, is a licensed pi-
lot with training in explosives. 15A.

On the road to history: Two Army soldiers man an Abrams tank Thursday in Karbala. The battle for
most technologically advanced army against an enemy that might try to use guerrilla tactics dating

A virtual certainty: Baghda

THE NATION'S N

50¢ PER COPY

2 QUARTERS
OR
5 DIMES

DIMES | QUARTERS

TO OPERATE

❶ Insert proper coins ❷ Wait for coins to drop
❸ Pull door & remove paper

COIN
RETURN
(PUSH)

USA TODAY

me terrain ▪ 10B, 1A

**rmed;
ished**

Despite light
resistance,
U.S. cautious

By Steven Komarow
USA TODAY

V CORPS ASSAULT HEADQUAR-
TERS, South of Baghdad — Meeting
only light resistance, U.S. forces
overran Baghdad's main airport
Thursday and took up positions
within striking distance of the cap-
ital. Allied commanders said Sad-
dam Hussein's government was
losing control of the country.

"There is increasing evidence
that the regime cannot control its
forces or the Iraqi population in
most of the country," Brig. Gen.
Vincent Brooks said in Qatar.

Brooks said special operations
units already were active around
the capital, infiltrating Iraqi com-
mand posts and securing bridges
and dams. Other intelligence
sources said U.S. operatives were
inside the city on clandestine mis-
sions. Renewed bombing was
heard in downtown Baghdad, and
the first major power outage of the
15-day-old war plunged the city
into darkness just after nightfall.

THE NATION'S NEWSPAPER

USA TODAY
NO. 1 IN THE USA

No.1
in the USA!

CALL NOW FOR CONVENIENT DAILY DELIVERY

1-800-USA-0001

⬆ COIN
RETURN USA TODAY

SPAPER

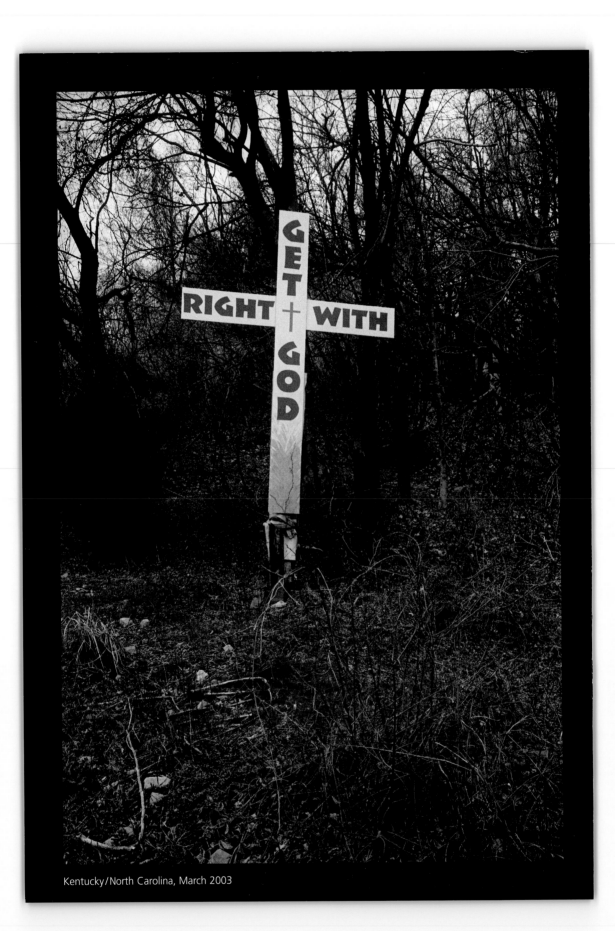

Kentucky/North Carolina, March 2003

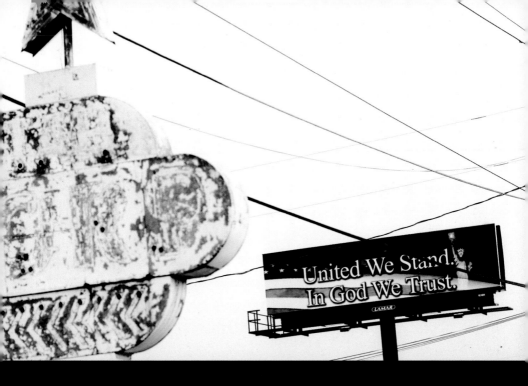

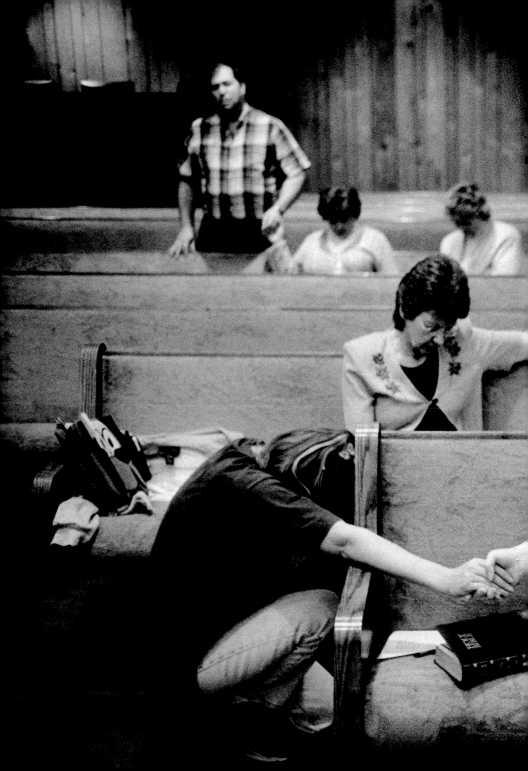

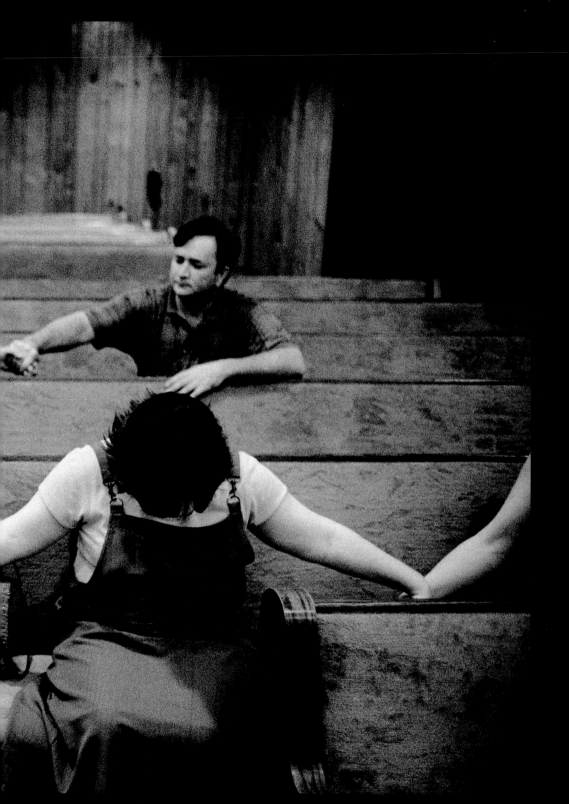

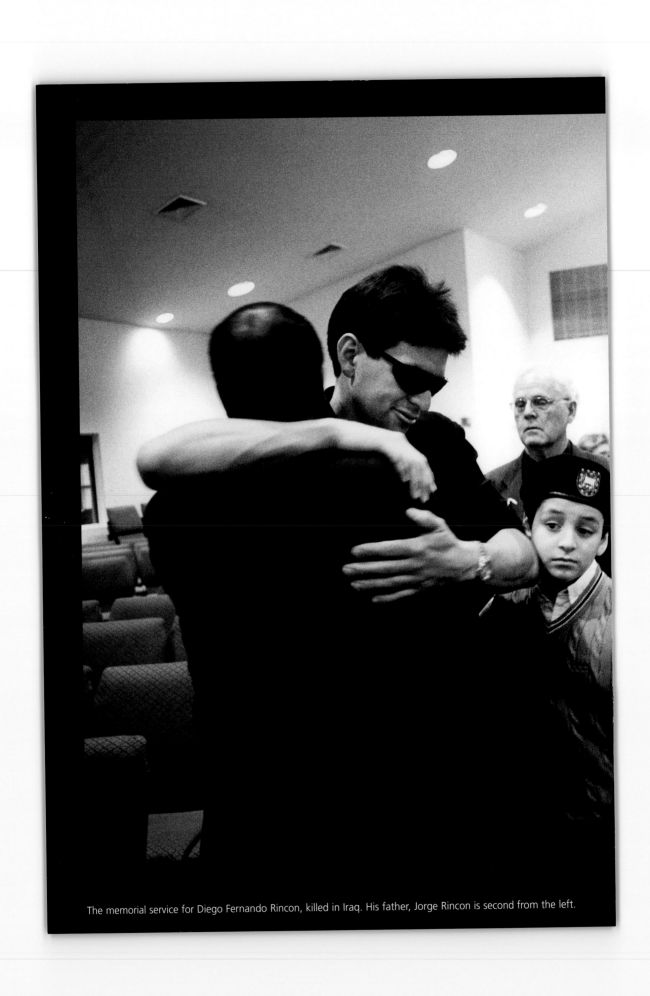

The memorial service for Diego Fernando Rincon, killed in Iraq. His father, Jorge Rincon is second from the left.

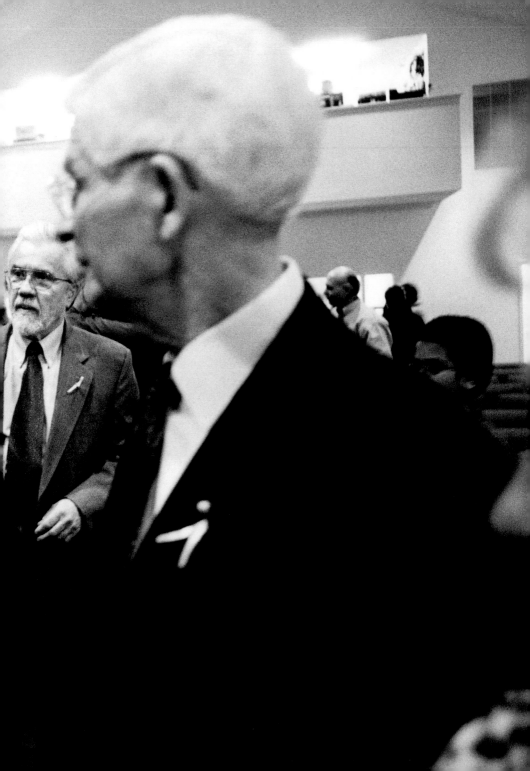

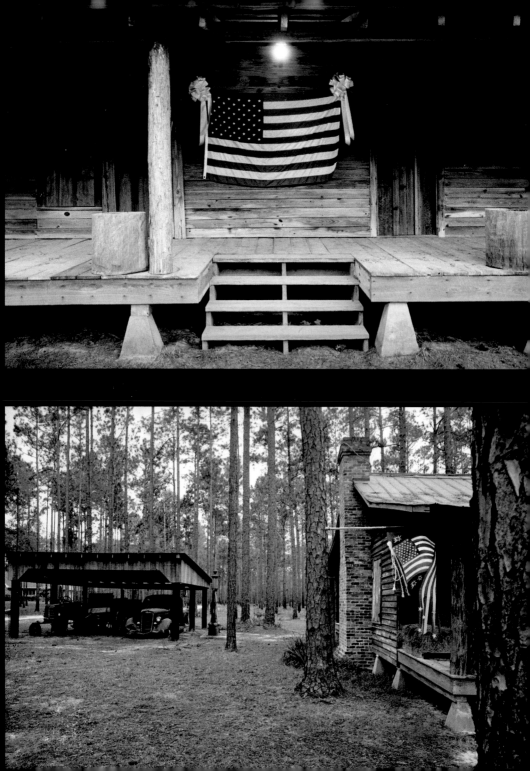

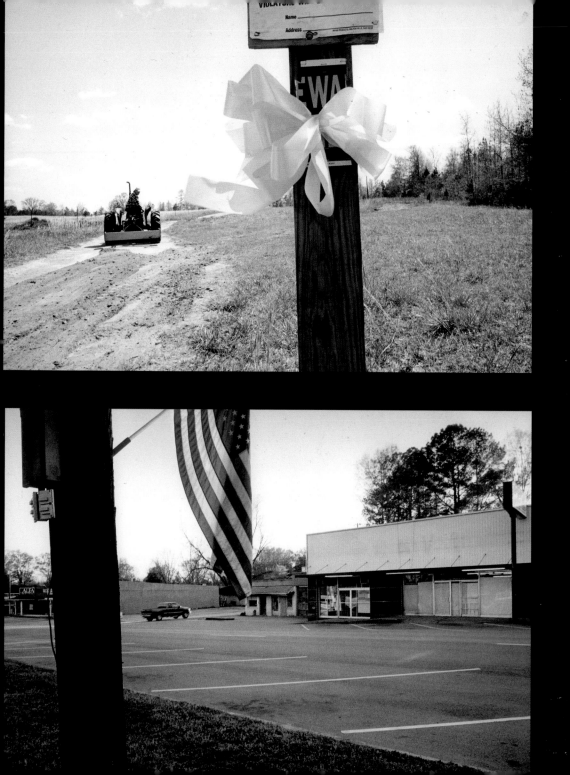

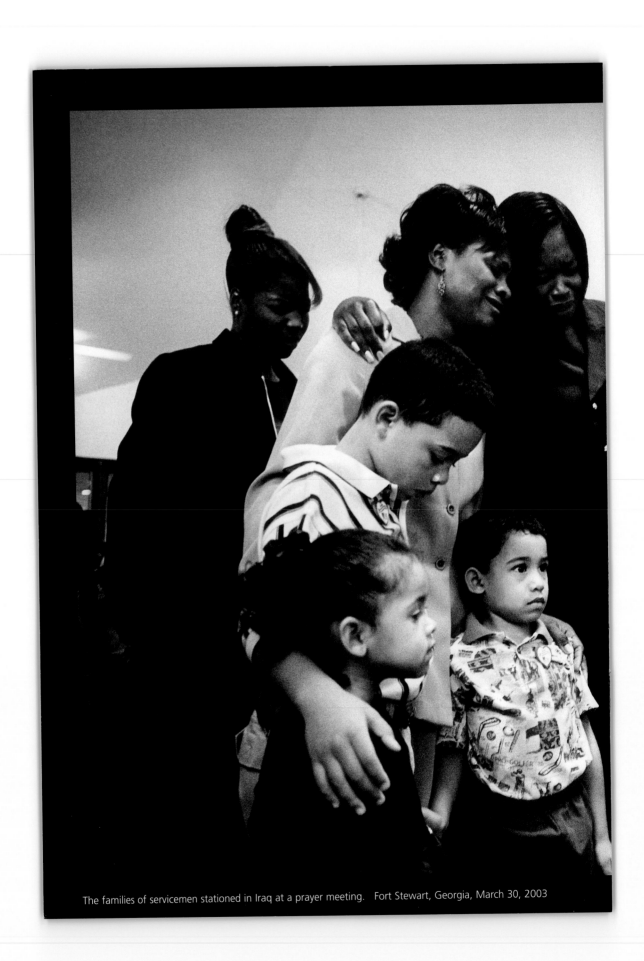

The families of servicemen stationed in Iraq at a prayer meeting. Fort Stewart, Georgia, March 30, 2003

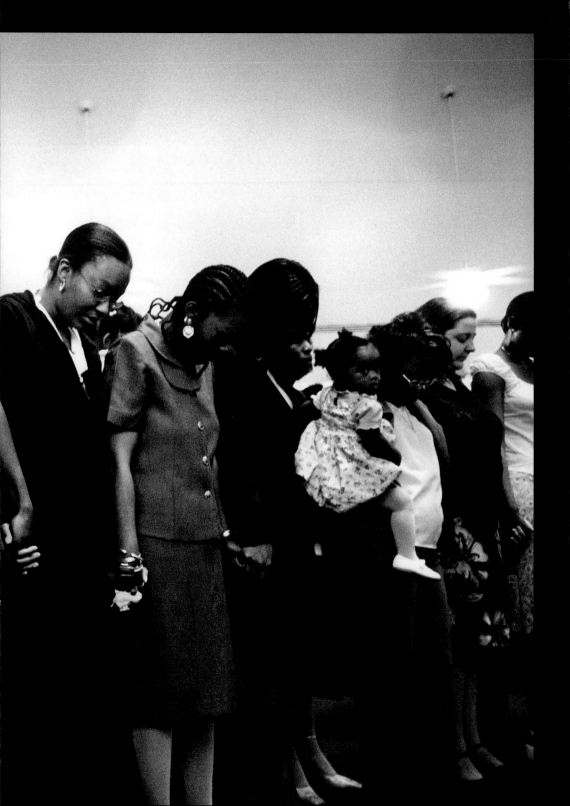

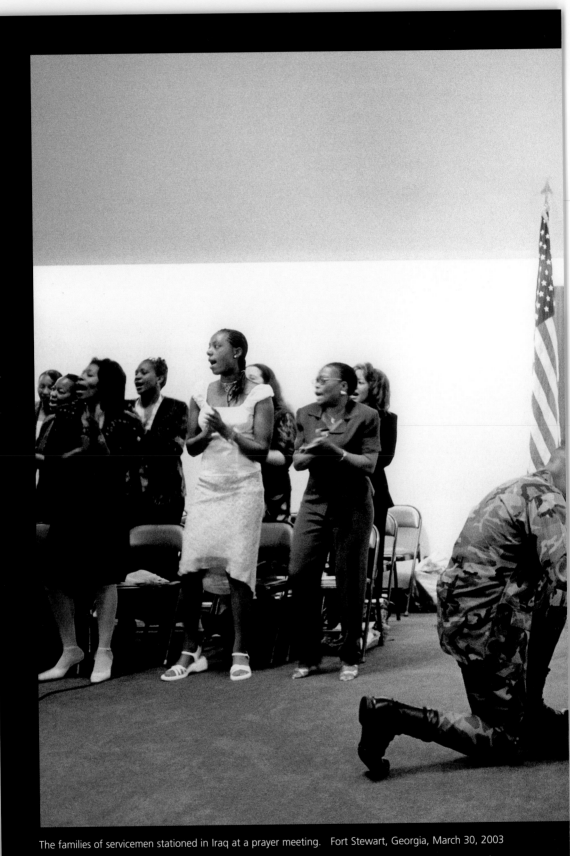

The families of servicemen stationed in Iraq at a prayer meeting. Fort Stewart, Georgia, March 30, 2003

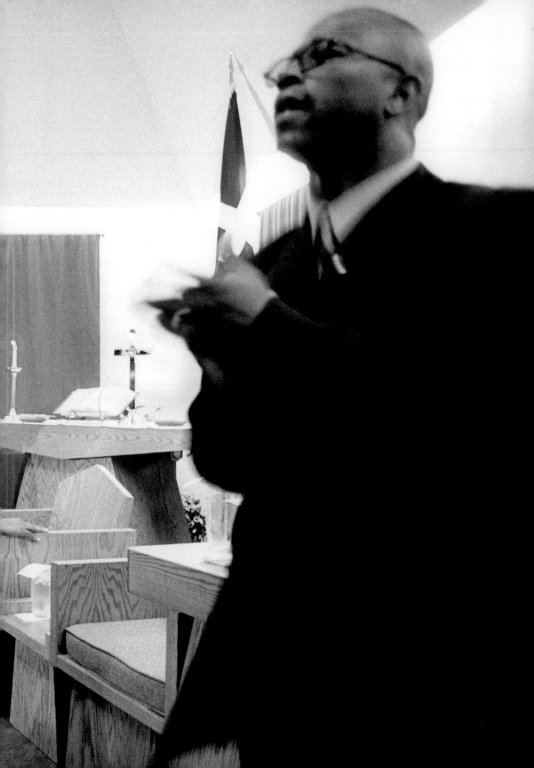

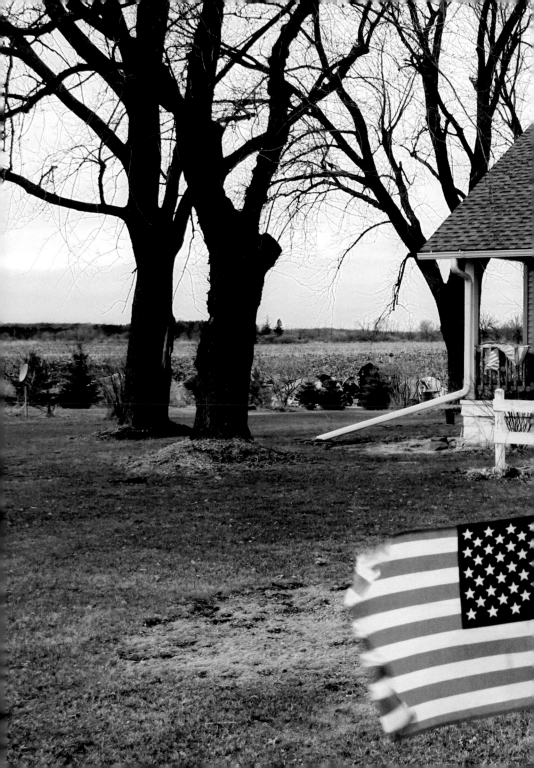

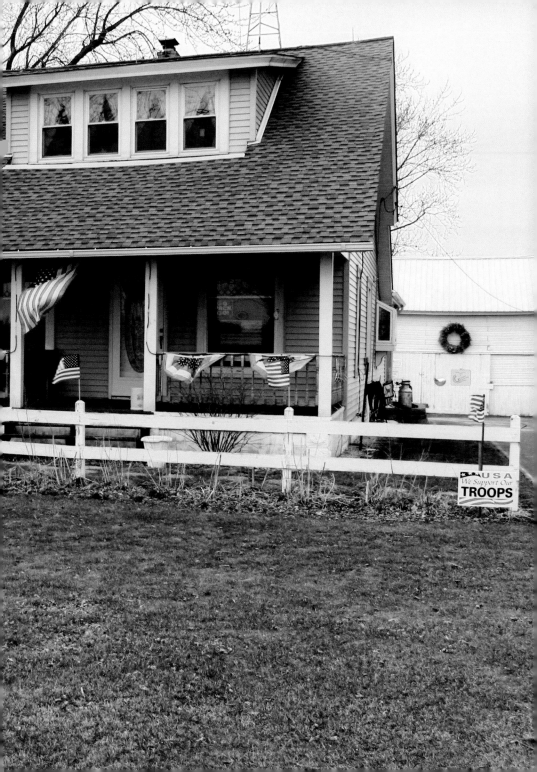

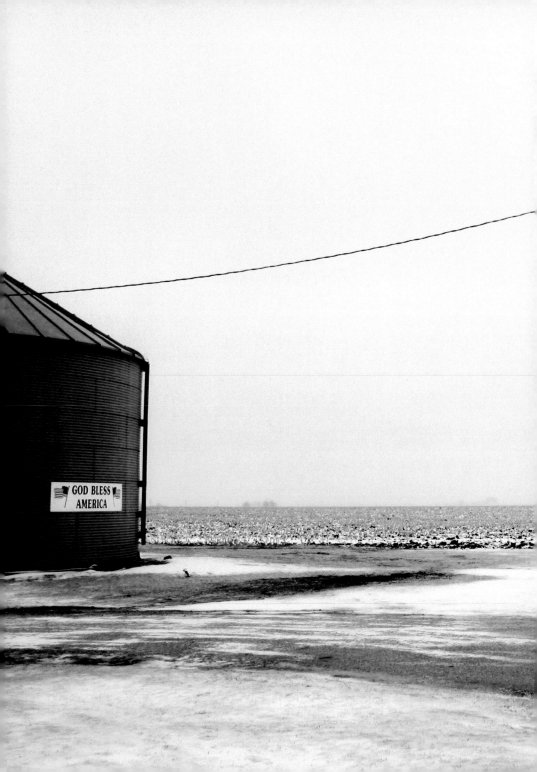

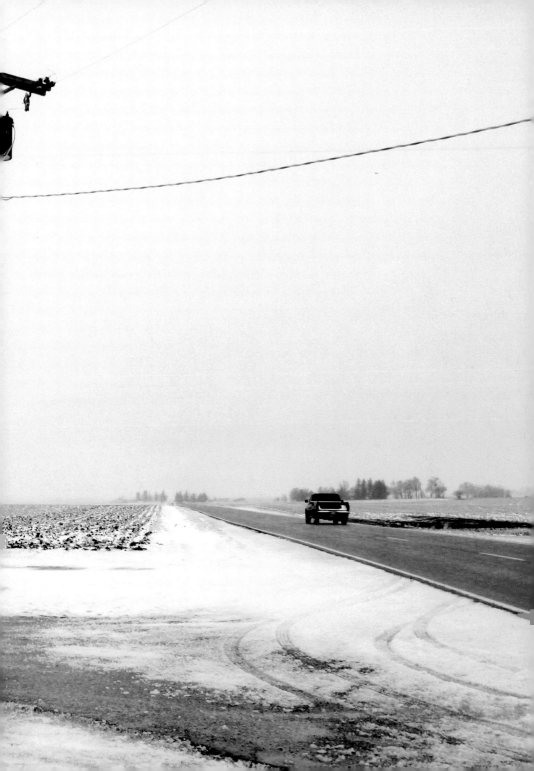

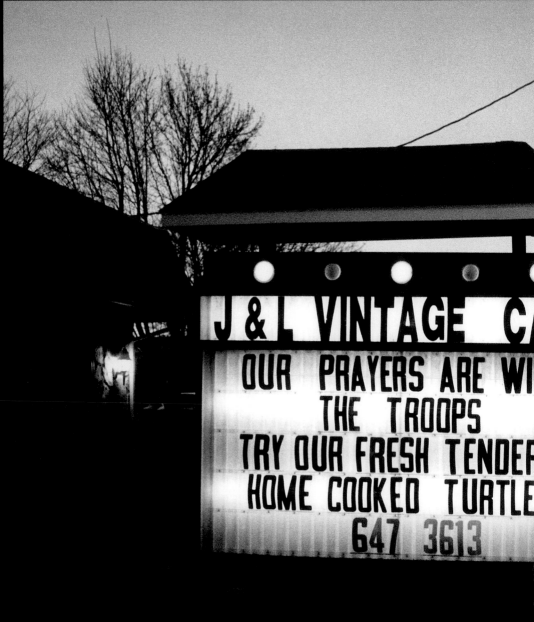

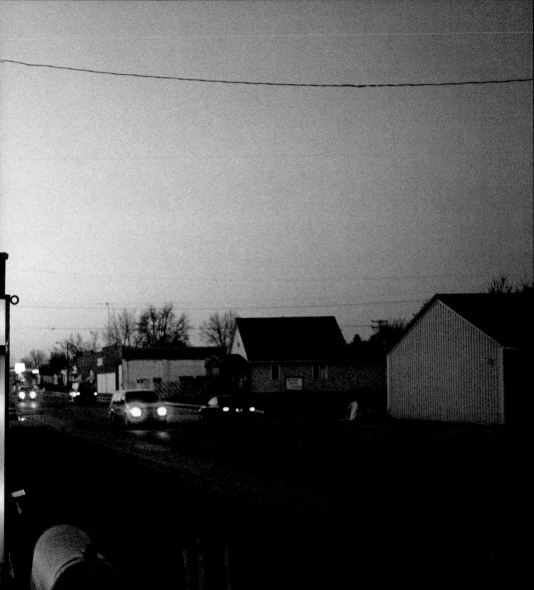

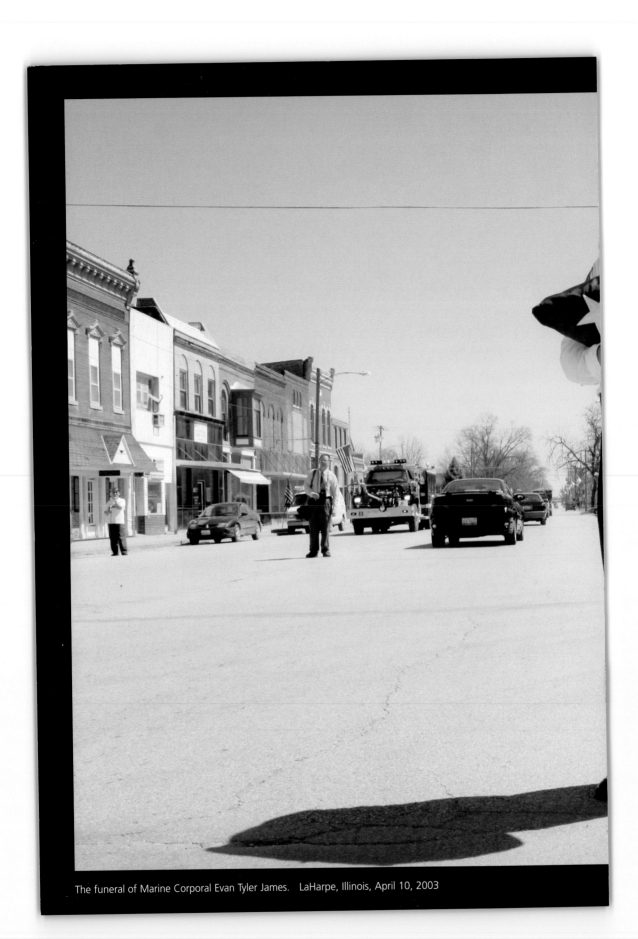

The funeral of Marine Corporal Evan Tyler James. LaHarpe, Illinois, April 10, 2003

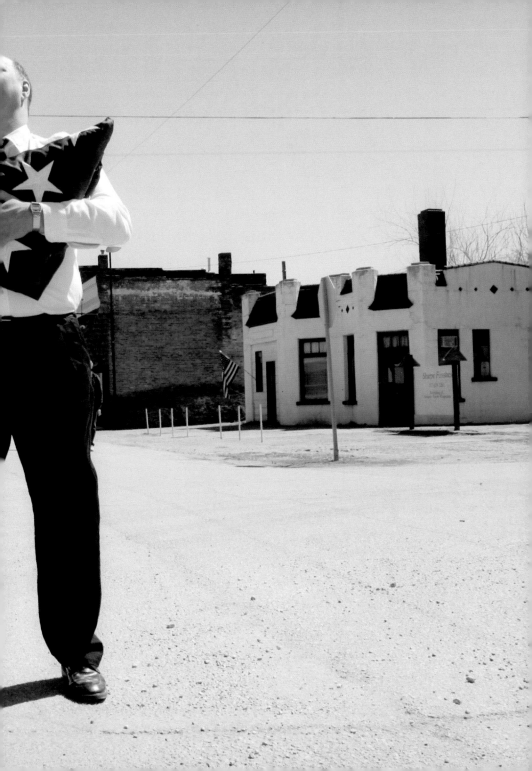

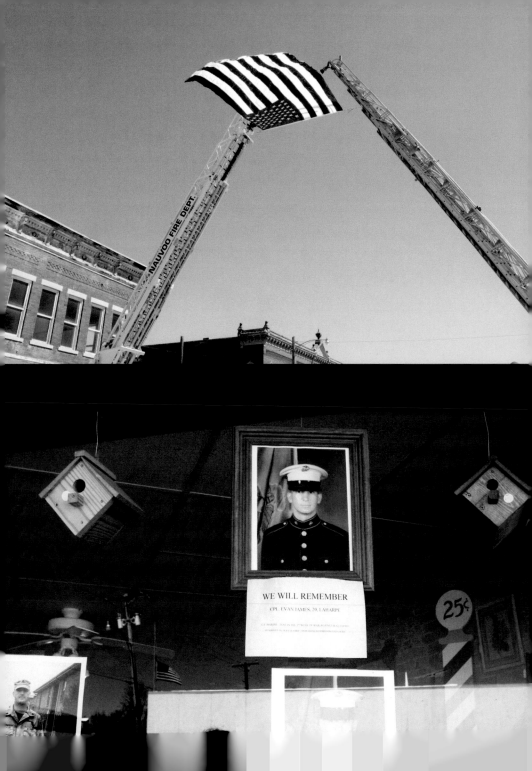

WE WILL REMEMBER

CPL. EVAN JAMES, 20, LAHARPE

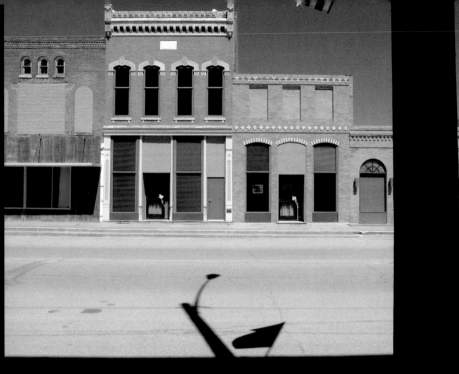

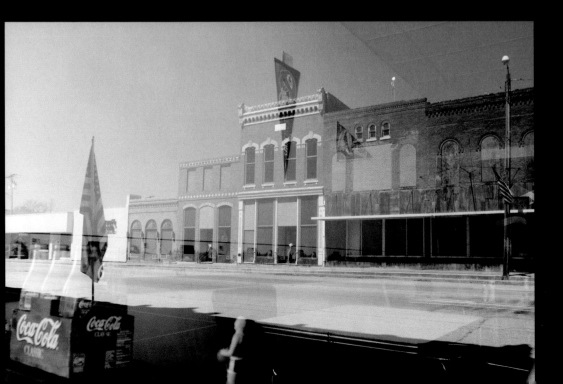

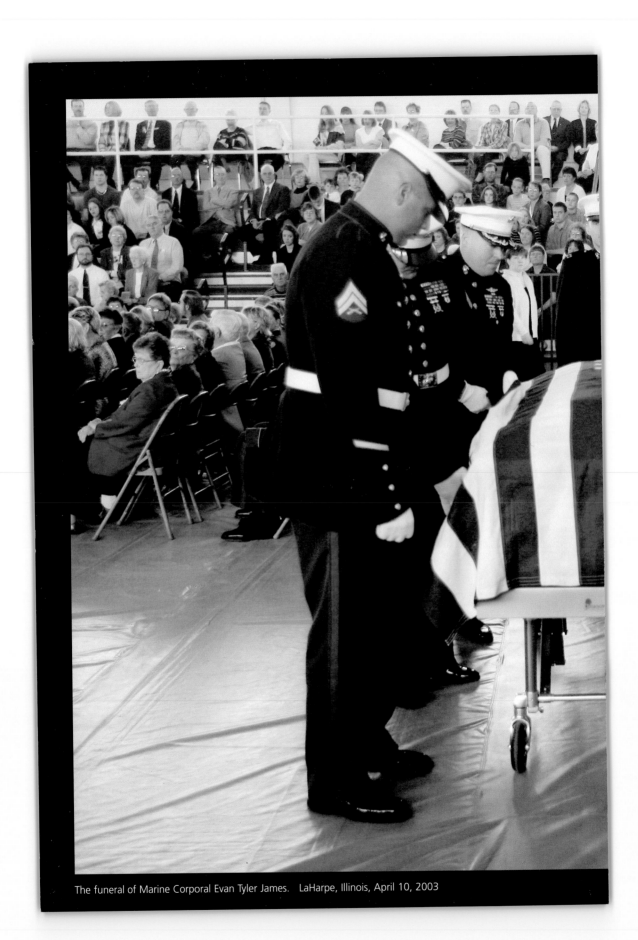

The funeral of Marine Corporal Evan Tyler James. LaHarpe, Illinois, April 10, 2003

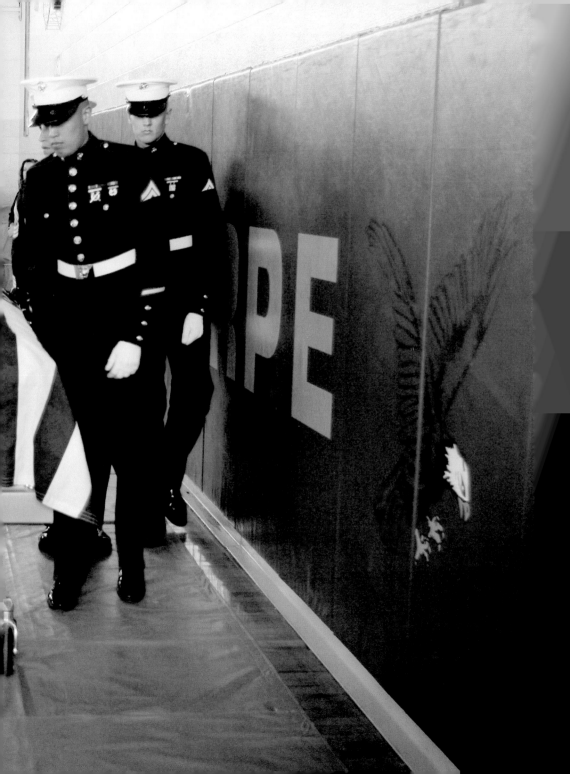

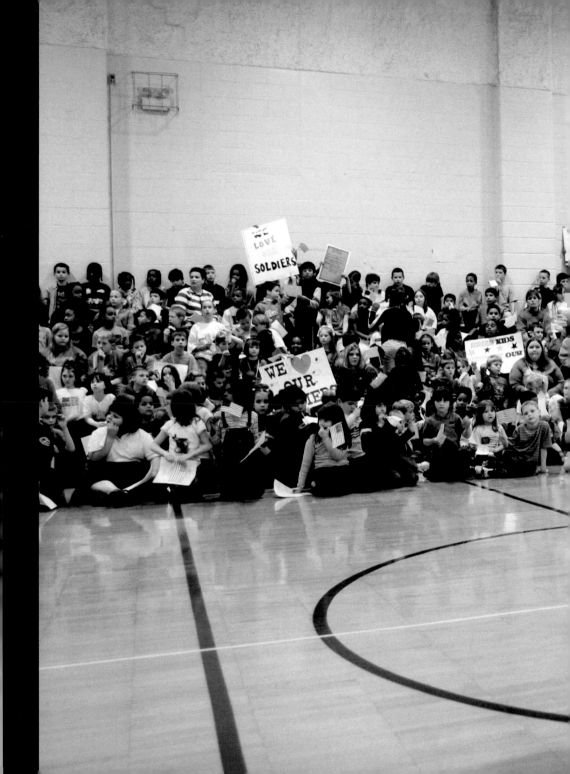

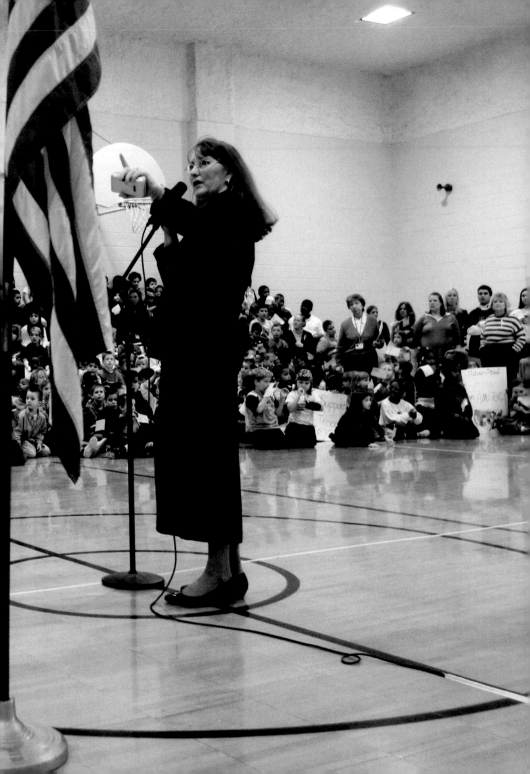

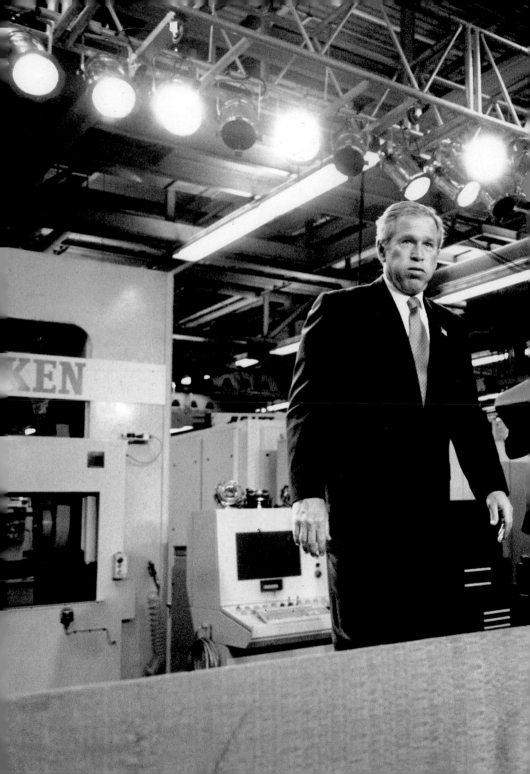

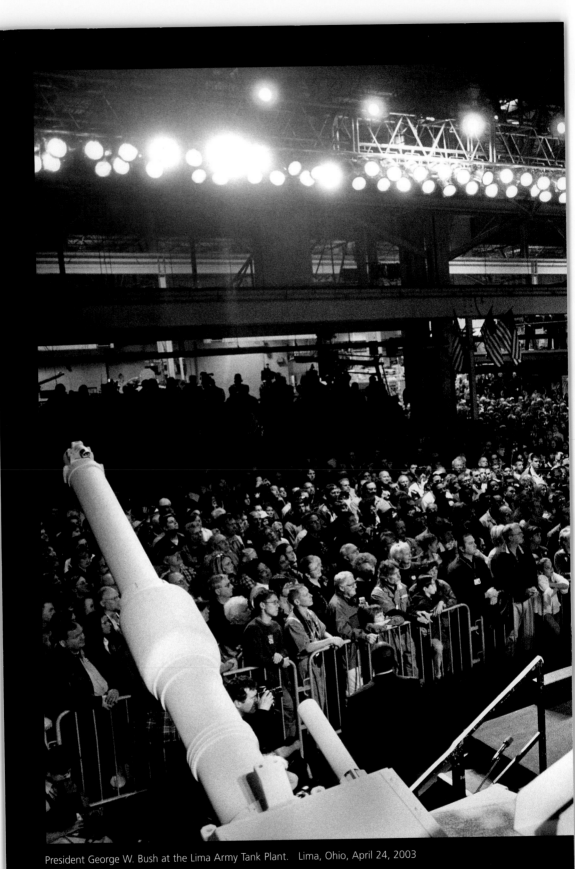

President George W. Bush at the Lima Army Tank Plant. Lima, Ohio, April 24, 2003

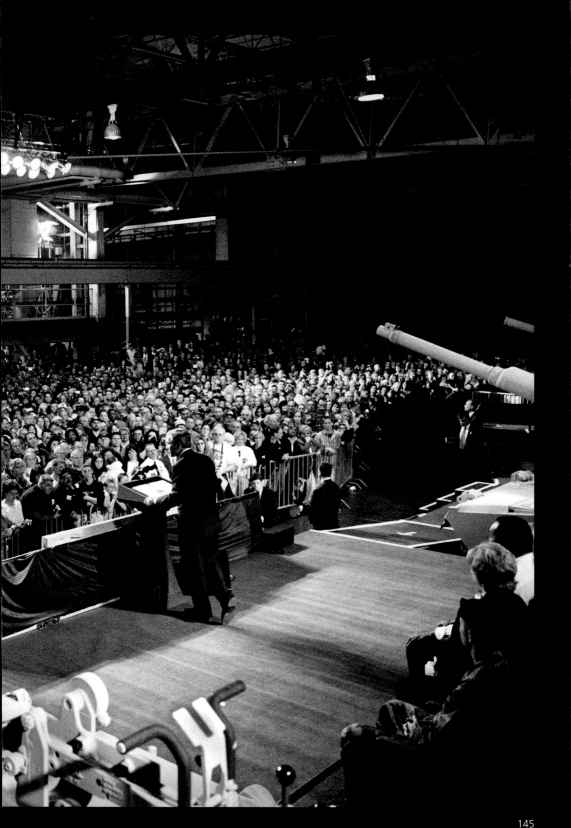

Peoria, Illinois, April 8, 2003

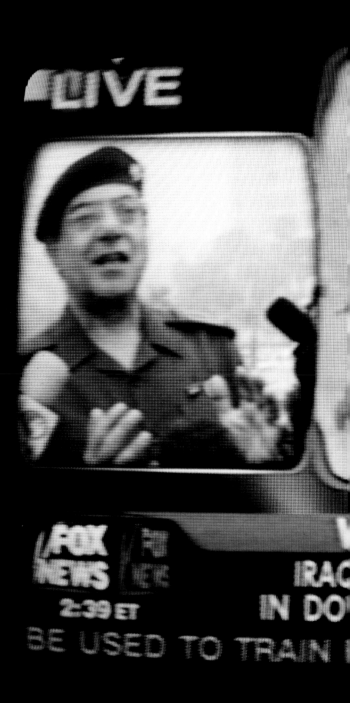

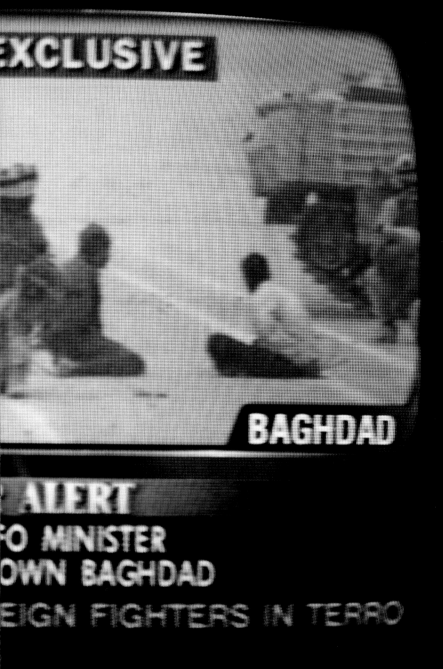

EXCLUSIVE

BAGHDAD

ALERT

O MINISTER
OWN BAGHDAD

EIGN FIGHTERS IN TERRO

Baghdad as U.S. troops occupy the parade ground. Madison, Wisconsin, April 7, 2003 149

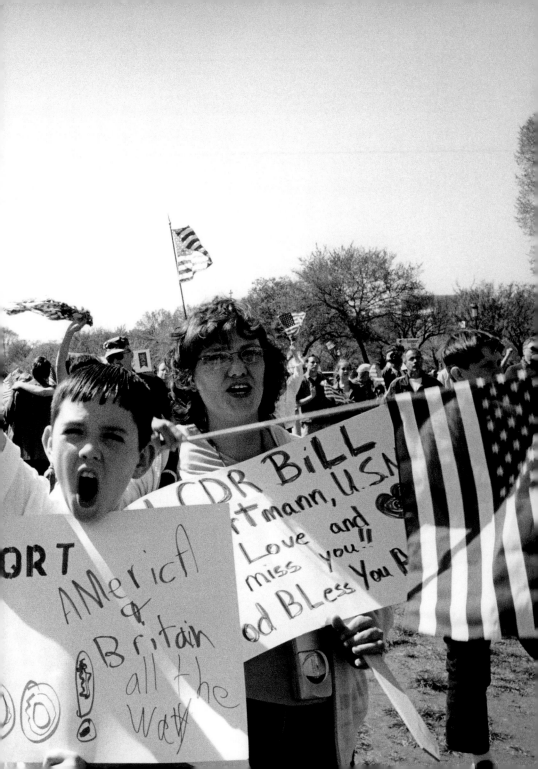

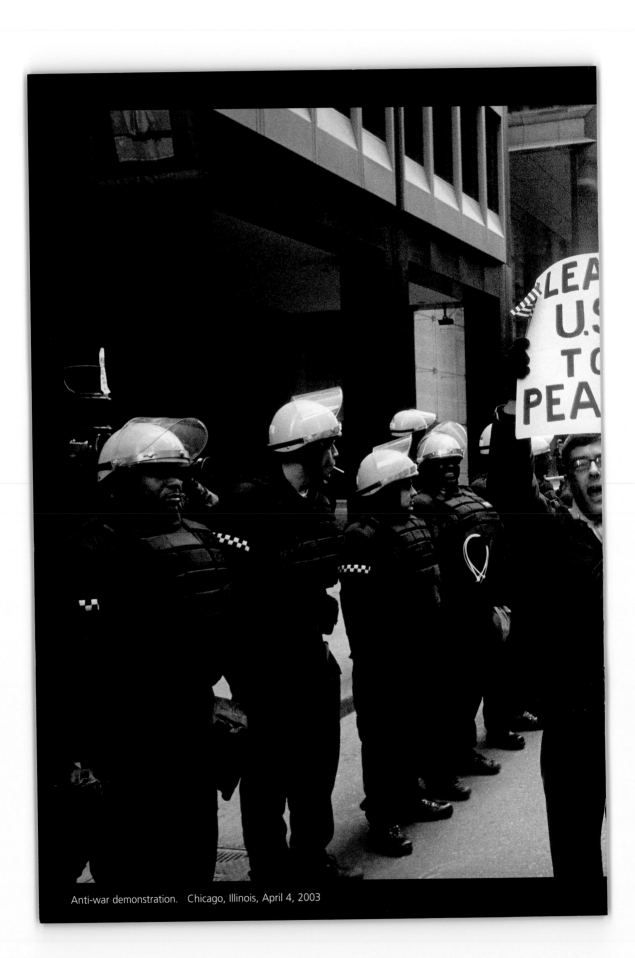

Anti-war demonstration. Chicago, Illinois, April 4, 2003

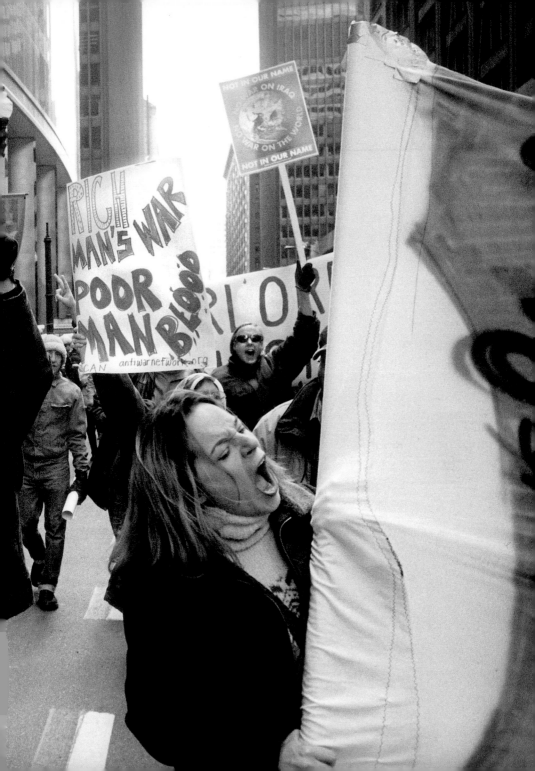

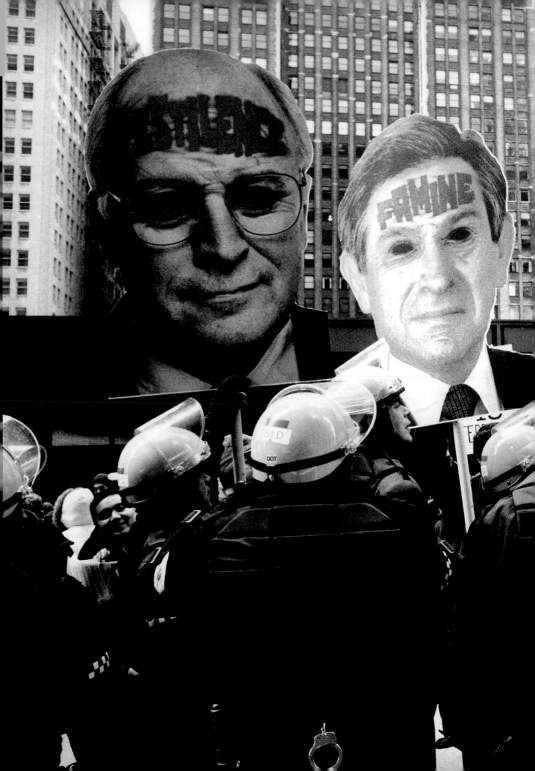

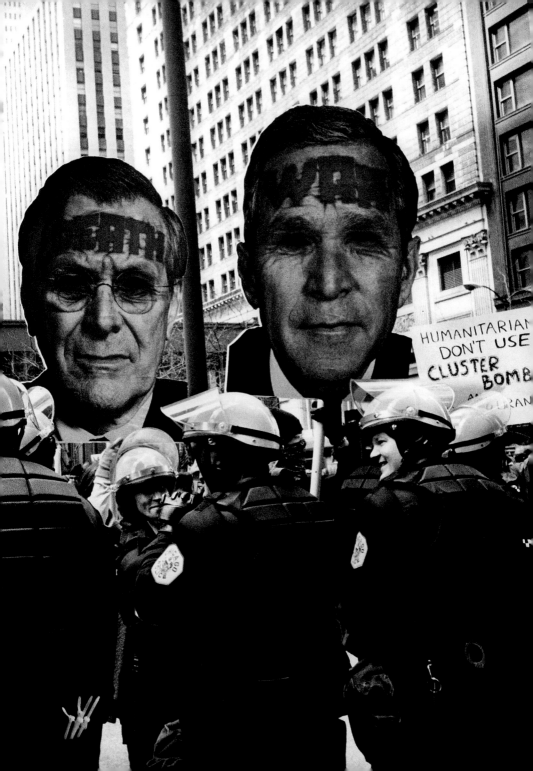

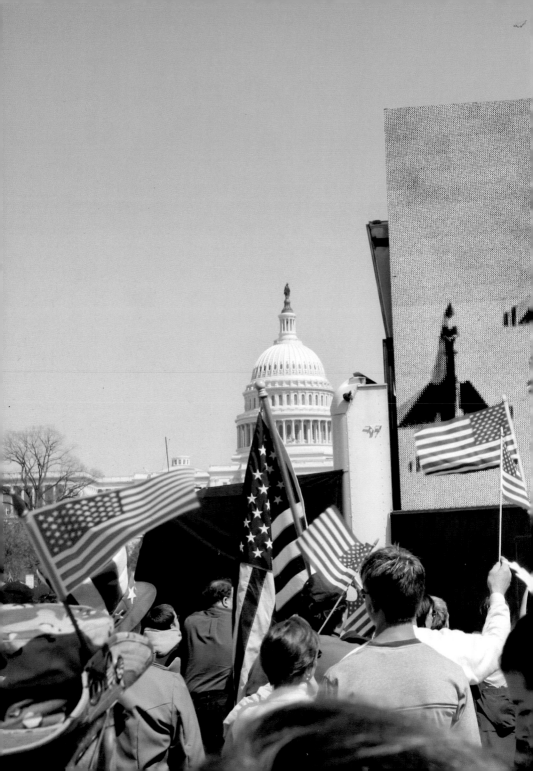

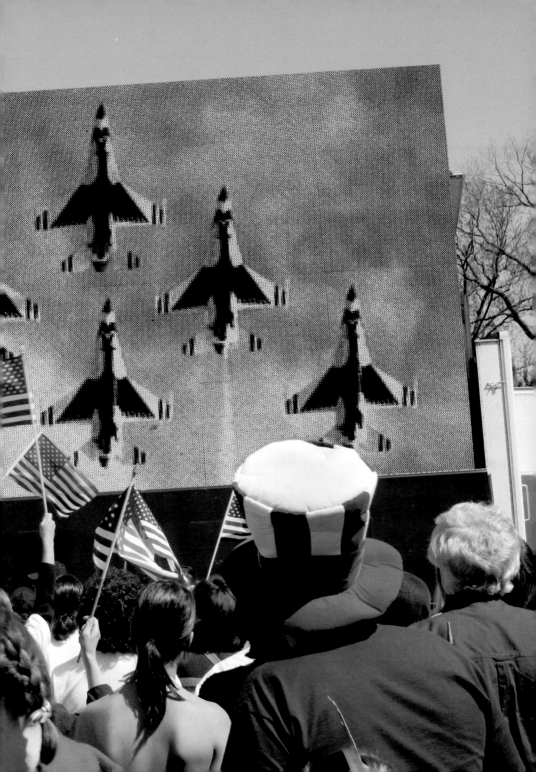

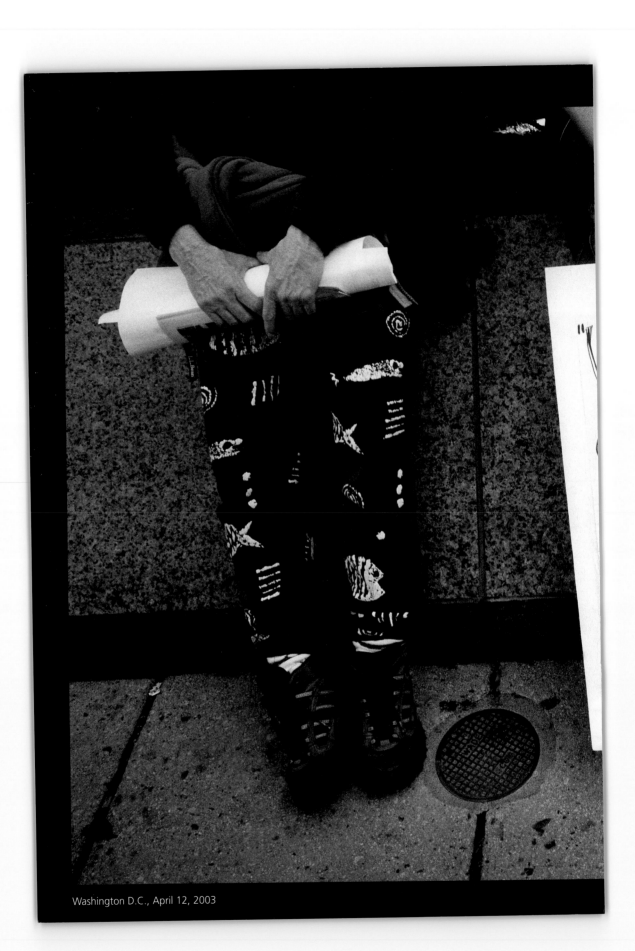

Washington D.C., April 12, 2003

e had a
at day. We
ed a lot of
people. "
"Liberation"?

Marine Sargeant
Eric Shrumpf

Chronology

May 1, 2003 to January 1, 2004

May 1 U.S. President George W. Bush announces, from the deck of the aircraft carrier U.S.S. Abraham Lincoln that "major combat operations in Iraq have ended." The U.S. has prevailed in the battle of Iraq and a "new era" has begun, says the president.

May 3 U.S. President George W. Bush says "Saddam Hussein had weapons of mass destruction," and it is a "matter of time" before U.S. troops find banned weapons hidden in Iraq.

May 6 The company formerly run by U.S. Vice President Dick Cheney, Halliburton, is to operate Iraq's oil facilities and to distribute the oil under a sole-source interim government contract.

May 9 The top U.S. commander in Iraq, Tommy Franks, says there is still "rough behavior" there —but his forces "will be up to it."

Graves containing up to 100 bodies—apparently of civilians—have been found near Basra, says Amnesty International. Amnesty suspects some of the victims were killed when the forces of the now-ousted regime of Saddam Hussein crushed a Shiite Muslim uprising in 1991.

May 11 U.S. forces directing the search for weapons of mass destruction in Iraq are likely to pull out in June after the group fails to find any biological and chemical weapons. They no longer expect to find such stocks, and had consistently found targets identified by Washington to be inaccurate, according to the *Washington Post*.

May 12 The Saudi authorities say 29 people were killed and nearly 200 injured in coordinated suicide bomb attacks against Western targets in Riyadh.

May 13 The International Institute for Strategic Studies in London, whose report last year was used to help justify the war, is puzzled about the failure to find banned weapons.

May 16 Five coordinated suicide bomb attacks kill 41 people and injure about 100 in Casablanca, Morocco.

May 22 The U.N. Security Council approves a resolution backing a U.S.-led administration in Iraq and lifting of economic sanctions.

The U.S. government is studying prewar intelligence reports on Iraq to see if it may have misjudged Baghdad's weapons program and links to terror groups, says the *New York Times*.

May 28 U.S. intelligence acknowledges finding no traces of biological warfare agents in specially equipped trailers seized in Iraq amid growing questions about the intelligence that supported the U.S. case for war.

May 29 U.K. Prime Minister Tony Blair becomes the first Western leader to visit Iraq since the war, as the row over weapons of mass destruction continues.

May 30 Vice President Dick Cheney's former company Halliburton has already garnered close to $600 million in military work related to the wars in Afghanistan and Iraq, and could potentially earn billions more without having to compete with other companies.

At a news conference during his Warsaw visit Tony Blair dismisses as "completely absurd" suggestions that Western intelligence agencies invented evidence of Saddam Hussein's weapons of mass destruction to justify the war in Iraq.

June 1 Tony Blair says, "Over the coming weeks and months we will assemble this evidence and then we will give it to people. And I have absolutely no doubt whatever that the evidence of Iraqi weapons of mass destruction will be there."

June 2 Tony Blair rejects calls for an inquiry into the government's claims about Iraqi weapons of mass destruction. "The idea that we doctored intelligence reports in order to invent some notion about a 45-minute capability of delivering weapons of mass destruction is completely and totally false," a clearly angry Blair tells reporters.

June 3 President Bush and Prime Minister Blair face allegations that intelligence was manipulated to justify war. A congressional inquiry is called to examine possible misuses of intelligence in the run-up to the Iraq war.

June 4 A senior Pentagon official holds a news conference to refute reports that defense officials had put a political spin on intelligence about Iraq's links to terrorism in order to build a case for war.

June 5 President Bush promises to "reveal the truth" about Iraq's banned weapons as intelligence officials voice fresh doubts.

June 6 A Pentagon report compiled before the war says there was "no reliable information" that Iraq had illegal weapons.

The BBC is told the dossier that claimed Iraq could launch a WMD strike in 45 minutes was sent back to Downing Street to be redrafted a number of times.

June 9 The U.S. Secretary of State Colin Powell insists Saddam Hussein did have weapons of mass destruction. Powell states, "We spent four days and nights at the CIA, making sure that whatever I said was supported by our intelligence holdings. Because it wasn't the president's credibility and my credibility on the line, it was the credibility of the United States of America."

June 11 The U.N. Chief Weapons inspector Hans Blix says "bastards" in Washington tried to undermine him before the Iraq war. According to Mr. Blix, as the U.S. build-up for an invasion of Iraq intensified, U.S. administration officials had pushed his weapons inspectors to use more damning language in their reports on Iraq.

June 16 A former Australian intelligence analyst accuses the government of manipulating evidence that led to the war in Iraq.

June 21 Ministers are confidant that Saddam Hussein's banned weapons will be found, says Downing Street.

June 23 Iraqi oil stored in Turkey is shipped for the first time since the war.

June 27 There is no evidence to support U.S. claims of a connection between Baghdad and Osama bin Laden, the U.N. says.

As the casualties suffered by U.S.-led forces in Iraq grow, a troublesome new low-intensity conflict emerges.

June 30 Downing Street says it is not "backing down one inch" in its dispute with the BBC over claims evidence on Iraq was "sexed up."

Defense Secretary Rumsfeld rejects the notion that U.S. forces are confronted with a guerrilla-style war in Iraq or stuck in a quagmire.

July 2 "The conditions are such that they can attack us there. My answer is, bring 'em on!," Bush speaking of the Iraqi resistance.

July 4 Al-Jazeera TV plays 10 minutes of an audio tape said to be the voice of deposed Iraqi President Saddam Hussein. Hussein says he is in Iraq mobilizing resistance against the U.S.-led coalition.

July 6 Tony Blair says the claim that 10 Downing Street "sexed up" the Iraq weapons dossier is a "serious attack" on his integrity.

A former U.S. ambassador who investigated alleged uranium procurement by Iraq says his findings were ignored.

July 8 The White House admits claims that Iraq tried to get uranium from Niger are wrong, undermining statements from George W. Bush and Tony Blair. The White House knew information about Iraq was false before George W. Bush used it in a speech, a CIA official says.

July 9 Senior British government sources no longer believe weapons of mass destruction will be found in Iraq.

July 10 Tony Blair still believes "products" of Iraq's illegal weapons programs will be found, despite doubts.

July 11 The Senate urges George W. Bush to seek support for U.S. troops in Iraq, amid unease about the U.S. exit strategy. The U.S. Senate unanimously approves a measure calling on the White House to consider requesting NATO and U.N. troops in Iraq.

A statement by the CIA Director, George Tenet, admits he failed to stop false claims about Iraq's nuclear weapons program from getting into a speech by President Bush.

July 13 Condoleezza Rice says Iraq did seek uranium from Africa—but this should not have been included in a presidential speech.

Former head of the U.N. weapons inspectors Hans Blix criticizes Tony Blair over the 45-minute claim on weapons of mass destruction.

The Iraqi Governing Council meets for the first time, as U.S. troops launch a new assault on anti-coalition elements.

July 14 Thousands of U.S. soldiers expecting to end their tour of duty soon are told they have to stay in Iraq indefinitely.

July 17 Both the U.S. and U.K. leaders are coming under fire from all sides, with anger growing about troops in Iraq and the intelligence used to put forward the case for war.

A taped message attributed to Saddam Hussein condemns as "lies" the U.S. and U.K. argument for invading Iraq.

The FBI opens an investigation into the origin of false documents that claim Iraq had attempted to buy uranium from Niger for an alleged nuclear weapons program.

U.S. experts warn that efforts to secure the allied victory in Iraq may fail unless efforts to establish public safety are extended throughout the nation within 3 months.

July 19 Police confirm Dr. David Kelly bled to death from a cut to his wrist, as Tony Blair comes under intense pressure over the Iraq dossier affair.

July 20 The BBC discloses that Dr. David Kelly was the principal source for its controversial report that an Iraq weapons dossier was "sexed up." Dr. Kelly reportedly warned of "many dark actors playing games" in an e-mail sent hours before his death.

July 22 Saddam's sons Uday and Qusay Hussein are killed in a gun battle in Mosul.

July 23 Donald Rumsfeld says the U.S. will release pictures of Saddam Hussein's sons to prove they are dead.

July 24 U.S. Vice President Dick Cheney launches a fierce defense of the decision to go to war in Iraq.

July 27 U.S. Deputy Defense Secretary Paul Wolfowitz says the use of "murky intelligence" is justified, if it prevents terrorist attacks.

July 31 The U.K. goes with claims that Iraq had bought uranium from Niger despite CIA skepticism.

August 5 Arab League foreign ministers rule out sending troops to help the U.S. stabilize Iraq.

August 7 At least 11 people are killed and more than 57 wounded by a truck bomb outside Jordan's Baghdad embassy.

August 8 The U.S. has made a lot of progress in the 100 days since the end of major combat in Iraq, President Bush says.

August 12 As the death toll among U.S. troops in Iraq increases daily, the Arabic press warns that the war of attrition against the coalition's military presence has no end in sight.

August 13 Coverage of the conflict in Iraq by Fox News helps propel Rupert Murdoch's News Corporation back into profit. Fox News' profits doubled during the conflict, as viewers switched from the main networks and other cable channels.

August 18 U.S. troops struggle to contain a fire on Iraq's main oil export pipeline following sabotage attacks.

August 19 A bomb attack at the U.N. headquarters in Baghdad kills 23 people including the U.N.'s chief envoy to Iraq.

August 21 The World Bank and the International Monetary Fund pull their staff out but remain fully engaged in the work of rebuilding financial institutions in Iraq.

U.S. troops hold one of Saddam Hussein's top generals, Ali Hassan al-Majid, known as "Chemical Ali."

August 25 The Red Cross cuts back its operations in Iraq amid fears of attack.

August 26 The charity Oxfam pulls out of Iraq after another aid agency there is warned it could be next on the terror hit list.

August 28 America signals that it might accept a U.N.-led multinational force in Iraq, but only under a U.S. commander.

August 29 Car bombs in Najaf kill 95 including Shia leader Ayatollah Mohammad Bakr al-Hakim and wound 200 others.

September 3 The U.S. calls on the Security Council to back a multinational force, but France, Russia, and Germany criticize the plan.

September 7 The U.S. president calls on U.N. members to put aside "past differences" and commit troops and money to Iraq.

September 8 George W. Bush says he will do whatever is necessary to bring security to Iraq, and asks Congress for $87.5 billion to help rebuild the country.

September 17 Former Chief U.N. weapons inspector Hans Blix says Iraq probably destroyed all its weapons of mass destruction more than a decade ago.

The White House denies ever linking Saddam Hussein to the September 11 terrorist attacks, even though U.S. President George W. Bush often cited those strikes in his case for the war in Iraq.

September 21 The U.S.-backed Iraqi council announces the sell-off of all formerly state-owned industries, except the oil sector.

September 23 President Bush, in a speech to the U.N., urges unity on the issue of Iraq and defends the U.S.-led invasion of Iraq.

September 25 A female member of the Iraqi Governing Council (IGC) dies after being shot in a gun attack in Baghdad. Akila al-Hashimi was the only member of the former regime to be appointed to the IGC and the first to be assassinated.

September 26 10,000 additional American troops are to be mobilized to Iraq and another 5,000 placed on standby, after other countries fail to pledge new forces.

September 30 The U.N. further scales down its presence in Iraq due to security concerns, leaving only 50 foreign staff members.

October 3 U.S.-led interim reporting by the Iraq Survey Group, led by David Kay, into the search for weapons of mass destruction says none have been found. The former U.N. chief inspector Hans Blix says it was to be expected. President Bush defends the decision to attack Iraq.

U.N. officials underline their intention to play no role in Iraq's political future unless the U.S. revises its proposals.

October 6 President Bush announces a new group that will give the White House greater control in efforts to reconstruct Iraq.

October 8 The Bush administration launches a new public relations drive to win back support for its Iraq policy.

October 16 U.N. Security Council approves an amended U.S. resolution on Iraq. The agreement gives new legitimacy to U.S.-led administration of the country, but stresses that power should be transferred to Iraqis "as soon as practicable." France, Germany, and Russia back the revised U.S. text, but will not contribute troops or funds.

The oil services and construction group Halliburton is accused of charging "inflated prices" when selling petrol to U.S. troops in Iraq.

October 18 A new message attributed to Osama bin Laden calls on the U.S. to withdraw from Iraq and warns of suicide attacks.

October 22 An internal memo by U.S. Defense Secretary Rumsfeld says the U.S. faces a "long, hard slog" in Iraq and Afghanistan.

October 23 The U.N. Secretary General makes a new attempt to persuade countries to donate money to help rebuild Iraq.

October 24 The Senate Select Committee on Intelligence prepares to issue a damning criticism of the quality of intelligence on Iraq before the war.

October 25 More than 20,000 protesters converge on Washington and San Francisco to demand an end to the occupation of Iraq by U.S.-led forces.

October 27 Five suicide bombings in the Iraqi capital, including an attack on the Red Cross office, kill 43 and wound 22.

The U.S. pushes for more help with Iraq at the G20 finance ministers' meeting, as the Federal Reserve chairman Alan Greenspan says the Iraq war has hurt the U.S. economy.

October 29 U.S. death toll (post-conflict) hits 116 exceeding war toll of 114. An estimated 13,000 Iraqis, including as many as 4,300 non-combatants, were killed during the major combat phase of the war in Iraq, a research group study reports.

October 30 The U.N. orders a temporary withdrawal from Baghdad of its staff for consultations on security.

The CIA is given a deadline to supply files on Iraq gathered prior to the war.

The House of Representatives backs President Bush's $87.5 billion package for Iraq and Afghanistan.

Many of the U.S. firms winning lucrative Iraqi reconstruction contracts have donated large sums to George W. Bush.

November 2 Fifteen U.S. soldiers are killed when their helicopter is shot down near the city of Fallujah.

November 3 The U.S. Senate approves $87.5 billion for Iraq and Afghanistan as attacks on U.S.-led forces continue.

November 8 U.S. officials say there may be as many as 260 mass graves in Iraq, containing the bodies of at least 300,000 people.

November 9 Seventeen people, including 5 children, are killed by a suicide bomb attack on a housing complex in the Saudi capital, Riyadh. More than 100 people are injured at the complex.

November 12 Eighteen Italians and 9 Iraqis are killed in a massive suicide bomb attack in the southern Iraqi city of Nasiriya, 84 people are wounded.

November 15 Announcement by the Iraqi Governing Council that the U.S.-led coalition in Iraq will hand over power to a transitional government in June 2004.

Twenty-five people are killed and 300 wounded when 2 car bombs explode almost simultaneously outside synagogues in Istanbul while worshippers are at their weekly prayers.

Seventeen soldiers are killed when 2 helicopters crash in Mosul, Iraq.

November 17 The U.S. launches a new operation against insurgents, arresting 99 "anti-coalition suspects" in a 24-hour operation across Iraq, according to the U.S. military.

November 20 Bomb attacks on the British consulate and HSBC bank leave at least 27 dead, including the top U.K. official in Istanbul, Turkey. 400 are reported injured.

100,000 to 200,000 demonstrators protest the visit of President Bush to Great Britain and topple an effigy of him in Trafalgar Square.

November 26 Iraqi's most senior Shia Muslim cleric, Ayatollah Ali Sistani, says the U.S. Iraq plan fails to give a sufficient role to the Iraqi people—or to acknowledge the role of Islam in Iraqi society.

November 27 President Bush pays a surprise visit to troops in Iraq for Thanksgiving.

November 29 Seven Spanish intelligence agents are killed in an ambush on Saturday and 2 Japanese diplomats die in a separate attack.

November 30 In the course of 1 month, 105 coalition troops are killed—the highest monthly death toll since the war began. U.S. death toll in Iraq reaches 436.

An ambush on U.S. troops in Samarra leaves 54 Iraqis killed by U.S. forces, claims the U.S. military. Witnesses say 8 of the dead were civilians.

December 4 U.S. Secretary of State Colin Powell, speaking in Brussels, uses the sharpest language yet to call on NATO members to take on a greater role in post-war Iraq. He is met with a cool reaction by the ministers of the 26-member organization.

December 9 Forty-one American soldiers are injured in northern Iraq in a suicide car bomb explosion outside a U.S. army base west of Mosul.

December 10 Companies from countries opposed to the conflict in Iraq will be barred from bidding for new rebuilding contracts worth $18.6 billion, the Pentagon says. U.S. Deputy Defense Secretary Paul Wolfowitz says the policy is necessary to protect America's "essential security interests."

The U.N. says it will run operations from Cyprus or Jordan because Baghdad is still too dangerous.

December 12 Halliburton, formerly run by Vice President Dick Cheney, may have overcharged U.S. forces in Iraq by some $61 million, a Pentagon audit has found.

December 13 Ousted Iraqi leader Saddam Hussein is held by U.S. forces after being captured in a "spider hole" at a farmhouse south of Tikrit.

December 14 At least 17 people die after a car bomb explodes at a police station.

December 16 President Bush says the ex-Iraqi leader should pay the "ultimate penalty" for his crimes—a sign that he wants the death penalty to be used.

December 19 The United States claims it will send about 2,000 extra troops to Iraq and asks 3,500 more to stay on longer.

December 21 The U.S. government raises the nation's terrorism alert status to the second-highest level, Orange.

December 28 Paul Bremer, the U.S. official running Iraq, contradicts Tony Blair's claim that Iraq had labs for developing weapons of mass destruction. It sounds like a "red herring" made up by someone to upset the rebuilding effort, states Bremer, unaware that the quotes had come from Mr. Blair.

December 31 Eight are killed and 30 injured when a car bomb explodes at a popluar Baghdad restaurant. Those hurt include 3 *Los Angeles Times* journalists and 4 staff members.

January 1, 2004 As of this date, 479 Americans have been killed in Iraq since the beginning of the war and 2,765 wounded.

Compiled from reports by: the BBC, the *New York Times*, the *Washington Post*, the *Los Angeles Times*, the *Chicago Tribune*, Agence France Presse, The Associated Press, and various Arabic newspapers.

Attacks on U.S. troops and Western organizations in Iraq. Birmingham, Alabama. October 27, 2003.

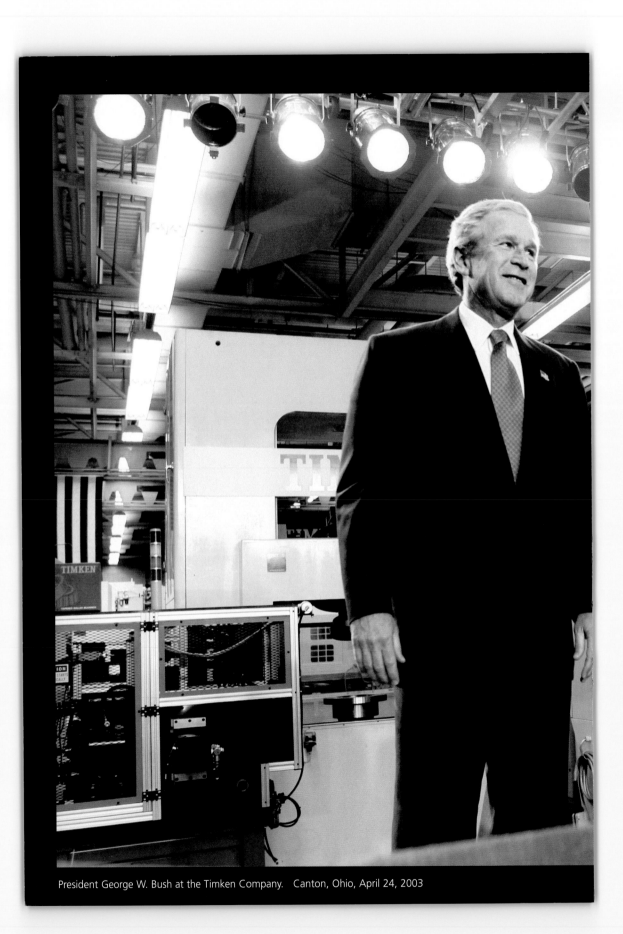

President George W. Bush at the Timken Company. Canton, Ohio, April 24, 2003

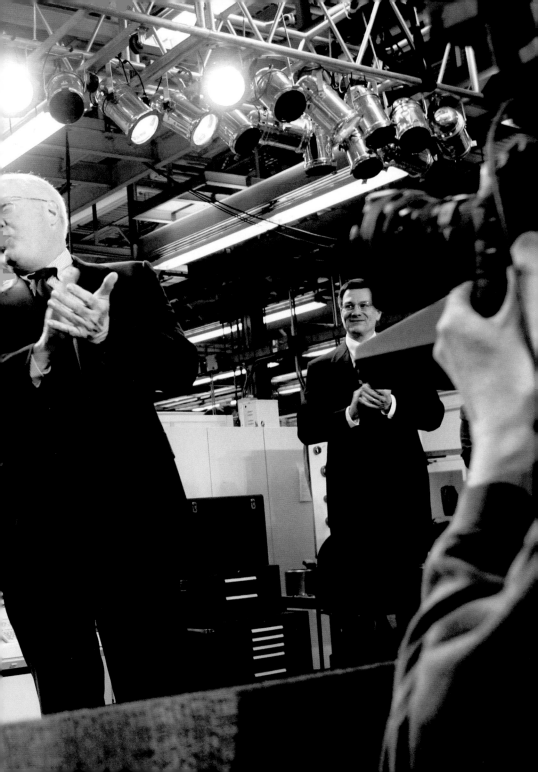

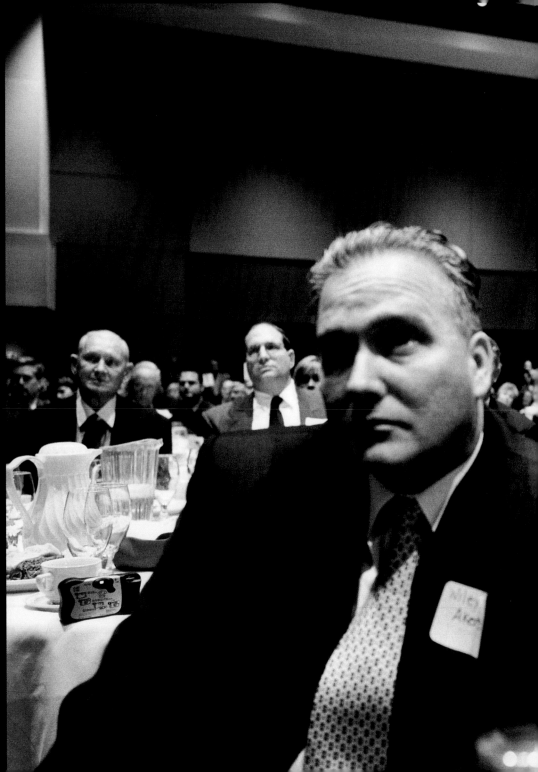

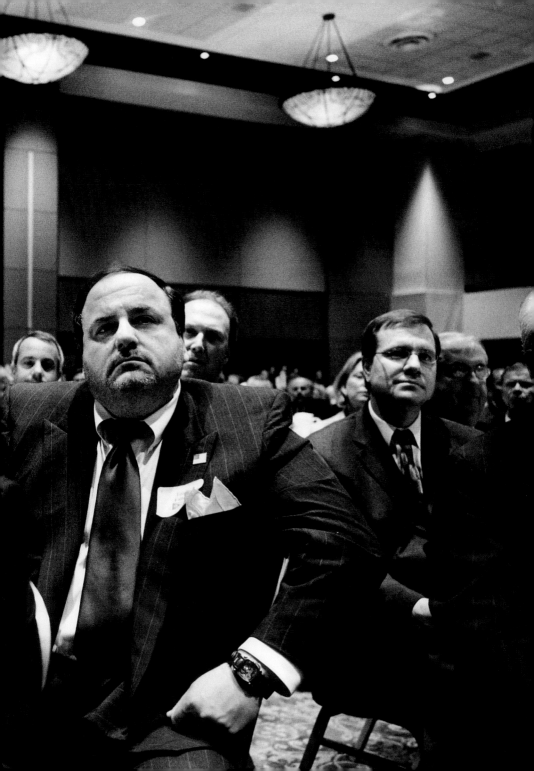

BBC WORLD
bbcnews.com

BREAKING NEWS

BREAKING NEWS

Capture of Saddam
SANCHEZ: SADDAM TA
WITHOUT RESISTANCE
MER: "WE GOT HIM." CNN

LIVE

BBC WORLD
bbcnews.com

SADDAM CAPTURE

Blair - "This is a time for celebration"

BREAKING NE

Capture of Saddam
U.S. FORCES CAPTURE
SADDAM HUSSEIN NEA
BREA

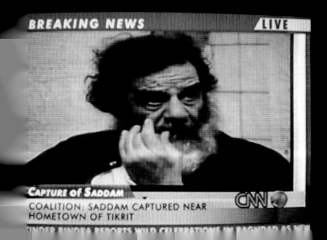

BREAKING NEWS LIVE

Capture of Saddam CNN
COALITION: SADDAM CAPTURED NEAR
HOMETOWN OF TIKRIT

UNDER BINDRA REPORTS WIID CELEBRATIONS IN BAGHDAD AS NE

BREAKING NE
AP

Capture of Saddam
SANCHEZ DETAILS HO
CAPTURED IN HOLE I
N. CNN SANCHEZ: Sa

NEWS CONFERENCE UNDER

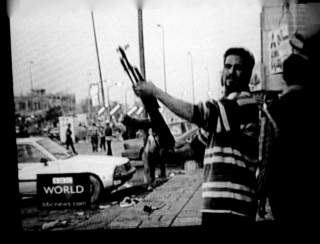

CNN

VS

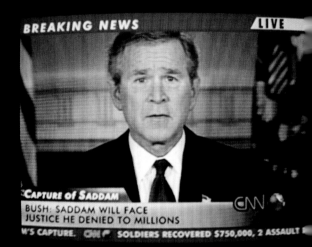

BREAKING NEWS

Capture of Saddam

BUSH: SADDAM WILL FACE
JUSTICE HE DENIED TO MILLIONS

N'S CAPTURE. CNN SOLDIERS RECOVERED $750,000, 2 ASSAULT

CNN

IS IN U.S. CUSTODY IN IRA

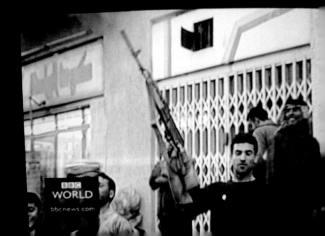

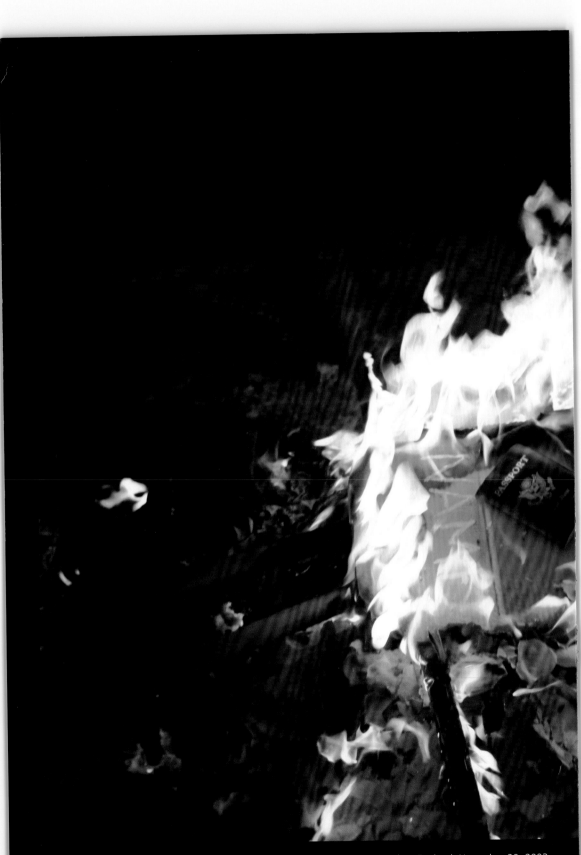

In protest of the U.S. government, young Americans burn their passports. London, England, November 20, 2003

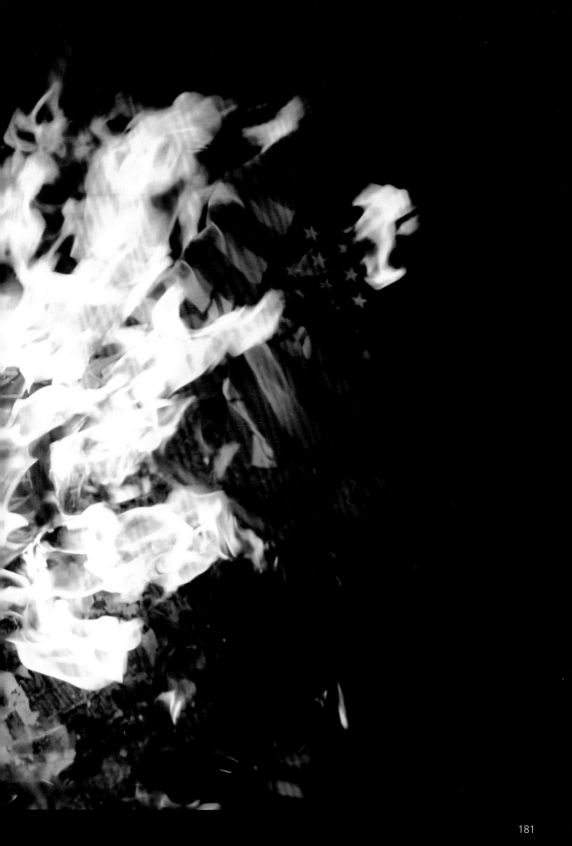

Acknowledgements

To MaryAnne Golon at *Time* magazine for seeing that these images were produced.
Also, thanks to Michelle Stephenson and Hillary Raskin at *Time* magazine.

To Stanley Greene, Philip Jones Griffiths, and Gilles Peress, for their editing advice.

Anthony Suau was born in the United States in 1956, and is currently based in Europe. In 1984, Suau won a Pulitzer Prize for his images of the famine in Ethiopia and is the 1996 recipient of the Robert Capa Gold Medal for his coverage of the war in Chechnya. In 1995, he published two books, one on the war in Chechnya and the other on the genocide in Rwanda. In 1999, Suau completed a ten-year project entitled *Beyond the Fall*, documenting the transformation of the former Soviet bloc.

Chris Hedges has been a war correspondent for twenty years, covering Central America, the Middle East, the Balkans, and Africa. He was a member of the *New York Times* team that won the 2002 Pulitzer Prize for Explanatory Reporting for the paper's coverage of global terrorism. He is the author of *War Is a Force That Gives Us Meaning*.

Library of Congress Control Number: 2004103406
ISBN: 1-931788-53-7

Editorial: Michael Famighetti
Design concept: Anthony Suau
Production: Lisa A. Farmer

The staff for this book at Aperture Foundation includes:
Ellen S. Harris, *Executive Director*; Roy Eddey, *Director of Finance and Administration*;
Lesley A. Martin, *Executive Editor*; Andrew Hiller, *Acting Managing Editor*; Andrea Smith,
Director of Publicity; Linda Stormes, *Director of Sales & Marketing;* Diana Edkins, *Director of
Special Projects*; Work scholars: Ursula Damm, Julie Anne Schumacher, Johann Vollenhoven

The purpose of Aperture Foundation, a not-for-profit organization, is to advance photography
in all its forms and to foster the exchange of ideas among audiences worldwide.

Aperture Foundation, including Book Center and Burden Gallery:
20 East 23rd Street, New York, New York 10010
Phone: (212) 505-5555, ext. 300. Fax: (212) 979-7759
E-mail: info@aperture.org

To subscribe to *Aperture* magazine write: Aperture, P.O. Box 3000, Denville, New Jersey 07834,
or call toll-free: (866) 457-4603. One year: $40.00. Two years: $66.00. International subscriptions:
(973) 627-2427. Add $20.00 per year.

Aperture Foundation books are distributed outside North America by:
Thames & Hudson Distributors, Ltd.
44 Clockhouse Road / Farnborough
Hampshire, GU14 7QZ
United Kingdom
Phone: 44 (0) 1252 541602 Fax: 44 (0) 1252 377380
Web: www.thamesandhudson.co.uk

Visit Aperture's website: www.aperture.org
Anthony Suau: www.anthonysuau.com

Printed in Italy by Artegrafica

First Edition
10 9 8 7 6 5 4 3 2 1